The Crafter's
Complete Guide to
Collage

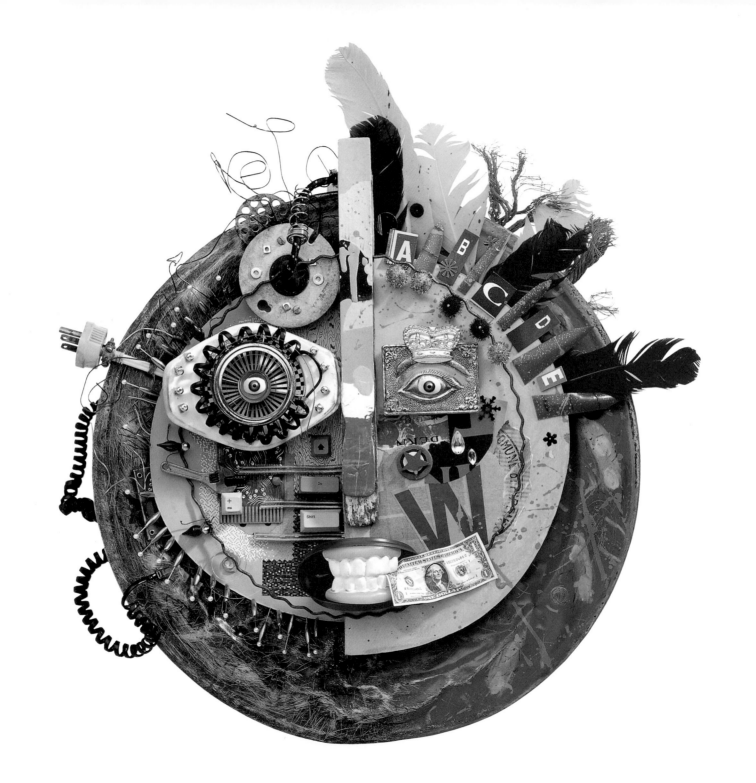

The Crafter's
Complete Guide to
Collage

Amanda Pearce

With contributions by

Sally Burton, Stephen Butler, Gerry Copp

Nina Davis, Jayne Dennis, Johanna Dennis

Watson-Guptill Publications

New York

Publisher's Note

The author, copyright holder and publishers have made every effort to ensure that all instructions given in this book are safe and accurate, but they cannot accept legal liability for errors or omissions or for any resulting injury, loss or damage to either property or person whether direct or consequential and howsoever arising. They would like to draw particular attention to the following:

When handling, using or storing chemicals, implements or any products mentioned in this book it is strongly advised to always follow the manufacturer's instructions; always store chemicals or similar products securely in their original containers, or clearly marked non-food containers, and keep them well out of reach of children and animals.

When using sprays or aerosol cans ensure eyes and exposed skin are protected. Always work in a well-ventilated area.

A QUARTO BOOK

Copyright © 1997, 2003 Quarto Inc.

First published in 1997 in New York
by Watson-Guptill Publications, Inc.,
a division of VNU Business Media Inc.,
770 Broadway, New York, NY 10003
Reprinted 1999, 2000, 2003

Library of Congress
Cataloging-in-Publication Data

Pearce, Amanda.
The crafter's complete guide to collage/
Amanda Pearce.
p.cm.
ISBN 0-8230-0258-6 (hc)
1. Collage. I. Title.
TT910.P43 1996
702'.8'12—dc20 96-45947
CIP

This book was designed and produced by
Quarto Publishing plc
The Old Brewery
6 Blundell Street
London N7 9BH

Senior editor: Gerrie Purcell
Editor: Maggi McCormick
Senior art editor: Clare Baggaley
Designer: James Lawrence
Photography: Martin Norris, Colin Bowling
Picture researcher: Miriam Hyman
Picture manager: Giulia Hetherington
Editorial director: Mark Dartford
Art director: Moira Clinch
Assistant art director: Penny Cobb

Printed in Singapore

Contents

Introduction

This book provides insights into the many forms of collage. The step-by-step technique demonstrations, practical projects, and inspirational galleries of work from many professional artists will help you develop a personal approach to creative collage work.

Collage is an exciting and versatile medium. You do not need technical skills – just an appreciation of shapes, textures, and colors.

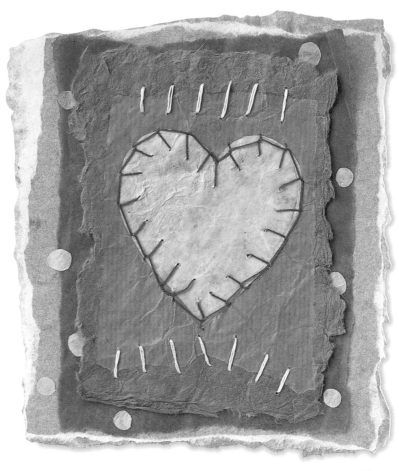

paper collage
Paper Heart – Amanda Pearce

The use of paper collage as an art form was pioneered early in the twentieth century by artists such as Pablo Picasso and Henri Matisse. They cut and pasted paper shapes and added them to their paintings. Matisse went on to create pure collage pieces with no painting at all. Since then, many artists have looked to the versatility of paper to help them create work.

Paper is a popular material, since it is inexpensive and readily available. Once the basics such as cutting, tearing, layering, exposing, and securing have been mastered, most other forms of collage can be tackled.

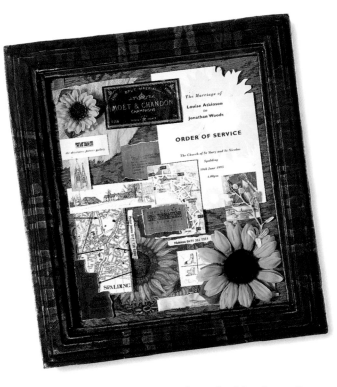

found-objects collage
Wedding Collage – Helen Atkinson

For those who hoard sentimental items gathered over many years, making a collage of found and collected objects is an ideal way in which to use items which otherwise have no particular purpose. Used bus tickets from a trip to the beach, leaves gathered on a country walk, a local newspaper headline, or old watch components can all be used to make exciting collage pieces to give as gifts or to create a memento of a special event.

The immediacy of collage can allow for a fast response, but collage also lends itself equally to a slower, more thoughtful approach. In the world of collage it is almost impossible to make mistakes! Sections of the collage can be made separately but not incorporated immediately, while you make decisions on composition and content. Shapes can be moved, added to, changed, or discarded.

The versatility of collage lies in the huge variety of materials which can be collected and used. From simple packaging papers, found objects, and fabric scraps to sophisticated computer images and cutouts from magazines, the list of potential materials is wide and makes collage accessible to many people.

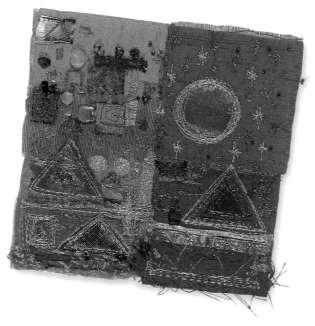

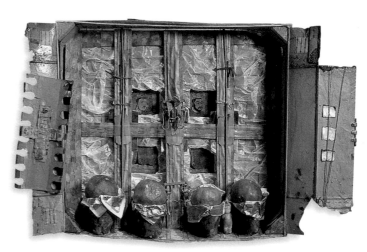

mixed-media collage
Greek Doorway – Phil Wildman

Using several media at the same time can lead to richly innovative work. Mixed media provides the opportunity to review techniques already covered as well as learn new skills. All manner of materials can be used, provided they are safe and can easily be connected: clay, paints, photo images, and papers can be combined to create exciting images suitable for a variety of projects.

fabric collage
Now – Jane Blonder

Fabric and threads offer an exciting medium for collage work. There is a long tradition of people using scraps of material to express family stories and local events. These images, rich in history and culture, were made into quilts, hangings, and pictures. Fabrics can be painted, dyed, stretched, cut, and layered – then glued or stitched together to show images from a still life and landscape or simple design ideas.

decorating 3-D objects with collage
Altar in Three Parts – Debra Rapoport

Imagine displaying fruit in a handmade collage-decorated bowl or wearing a piece of your own handmade collage jewelry. The section on decorating 3-D objects explores not only the application of collage to handmade papier-mâché objects, but also how to make the objects themselves.

Choosing a theme

Before artists and designers begin a new piece of work, they decide upon a main subject or theme. This does not mean that you cannot use ideas from several sources, but it helps to focus on one area at a time so as not to get confused.

The projects in this book have been designed to give you a starting point for work, and we provide the themes for you. The information in the next section will help you begin to develop ideas for your design work as you progress and will also give you an insight into the methods designers employ to create designs.

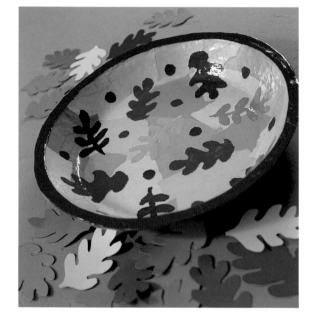

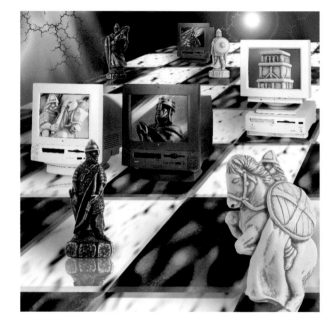

découpage collage
Bowl – Linda Barker

Découpage, the technique of pasting cut and torn images onto existing objects, has long been a way for people to revamp old household objects. It is a particularly versatile way to make use of old greeting cards, magazine cutouts, tissue papers, tickets, stamps, and wrapping paper. Images can be built up quickly, without mess, making this an ideal technique for those without much space for working.

photomontage collage
Houses – Wendy Wax

Like découpage, photomontage provides a simple and immediate way of constructing images using photographs, photocopies, and cutouts. Possibilities are endless – snapshots can be cut up and rearranged to create personal reminders of a trip; photocopiers can be used to manipulate your own photographs and combine them with magazine cutouts.

computer collage
Computer Chess – Richard Holloway

Computer design uses collage techniques such as cutting, repeating, layering, and pasting images. Finished work can be extremely sophisticated and has the additional bonus that it can be changed in scale or slightly altered and then reprinted. Photographic images and existing design work can be scanned, so complicated areas of work can be repeated and placed in layers elsewhere on the screen.

It is important that you pick a theme which really interests you so that you don't get bored and run out of ideas quickly. If you are not sure how to pick a theme, try thinking about what you like to read or talk about.

Inspiration: themes and ideas

The most ordinary things can trigger design ideas and form a starting point for your work. Trees on a winter evening, sheets of music laying on a patterned carpet, an ocean view, or dishes on a checked tablecloth are all commonplace sights which are rich in visual ideas.

Gathering resource material

The first thing to do after picking a theme or subject that you wish to work with is to gather cutouts, photographs, and pictures which tie in with this theme. Also start to collect objects and trinkets, such as labels, wrappers, tickets, fabric swatches, leaves, and so on, which can help create a mood or look that works with your subject. There are no rules about what to collect as long as you like one aspect of each thing you add to your collection. The important thing is to create a personal "design board" of ideas which inspire you.

An ideal way to display these things is either in a sketchbook or on a pinboard. Each method has its advantages – a sketchbook can be carried around and you can constantly add things and make notes. A pinboard placed on a wall near where you work will provide constant visual ideas. You may find it useful to arrange the images according to color or subject matter. For example, put the images showing nature together, pictures with water in one area, and so on.

Developing ideas

The next step is to begin to use your collection as a starting point. Look at the images you have assembled and try to decide what you like best about each one. It may be the colors, shapes, patterns, outlines, or textures. For example, look for the most startling shapes, or unusual combinations of color.

Once you have decided which elements you like best, think about how you can use them as a starting point. The important thing is to avoid simply copying the information you have collected. Your work will be much more personal if you customize the ideas. Consider altering the size and scale of any shapes you like, changing the colors of a pattern, laying one shape on top of another to create a new shape, or enlarging one area of a pattern and drawing a giant-sized version.

Your sketchbook should become a personal notebook of impressions, and used to write down thoughts and sketch ideas. Use different media – try pencil, pen, pastel, and crayons. Don't worry about creating finished pictures. At this stage just work up rough ideas for development.

As you work through the techniques in this book and experiment with different materials, you will become more confident and may want to make some of the projects using your own images. This stage of designing should provide you with some ideas for images to use in your own collage work.

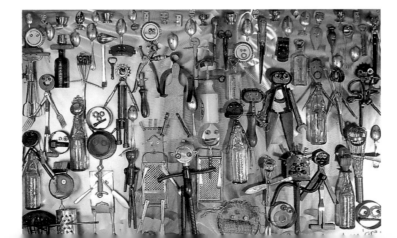

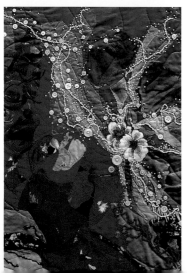

The previous section focused on developing ideas for your design work. This one looks at developing color work. All artists and designers need a basic understanding of color in order to experiment with it in their work.

Creative colors

Basic color mixing

The building blocks of color are the three primary colors: red, yellow, and blue. These three colors cannot be mixed from any other colors. If you mix the primary colors with each other, you make the secondary colors, violet, green, and orange. In theory this mixing process will produce clean colors, but in reality, mixing red and blue usually produces a rather brownish violet. An improved result may be achieved by adding a little white when you mix these two colors.

A further range of colors can be produced by mixing the secondary colors – green and violet; violet and orange or orange and green. The resulting neutral colors will vary according to the proportions of each color used.

When two of the primaries are mixed the resulting color is a complementary of the primary which has not been used. For example, when blue and yellow are mixed the resulting green is the complementary of red. When placed together complementary colors will accentuate each other. Adding white to a pair of complementary colors will produce a range of chromatic grays, grays with a color leaning. Chromatic grays can be used in place of gray made with black-and-white, which can sometimes appear flat.

When a basic color is lightened by the addition of white, the resulting colors are known as tints of the basic color. When lightening a color, always add the basic color to the white a small amount at a time. A basic color can be darkened by the addition of black or another darkening color (for example, brown or dark blue). The resulting colors are called shades of the basic color. When darkening a color, always add the darker color to the basic color a little at a time to avoid making it too dark too quickly.

Colors take on a different appearance depending on which colors are used around them. It is essential that you always compare the colors that you are going to use to assess the effect they have on each other.

Building a color notebook

It is not always necessary to observe the rules of color. Many artists in the past have achieved notoriety because they broke these rules. Color palettes are very personal; where one artist may experiment in every piece of work he or she produces, another will have a more limited palette of colors. What is important is that as an artist you experiment until you find colors that suit you. Building a color notebook can help provide a working dictionary of color which allows you to constantly assess which colors work together, and which excite you.

Your notebook can be built up in much the same way as your sketchbook. Start by collecting anything colored that interests you, such as fabric swatches, magazine snippets, discarded wrappers, or photographs. Paste all of these samples into your sketchbook, a notebook or a ring binder.

Practice mixing paint colors and rubbing crayons or pastels together to create new colors. One useful exercise is to take a favorite picture and try to recreate some of the colors on it. Place the results of this color mixing near swatches and cutouts that have similar coloring.

Whenever you see an interesting combination of colors, make a note of them to place in your notebook. In building ideas up like this, you will soon have a notebook of color ideas which you can use in your design work.

Mixing colors: Basic notebook

The building blocks of color are the three
PRIMARY colors:

RED *BLUE* *YELLOW*

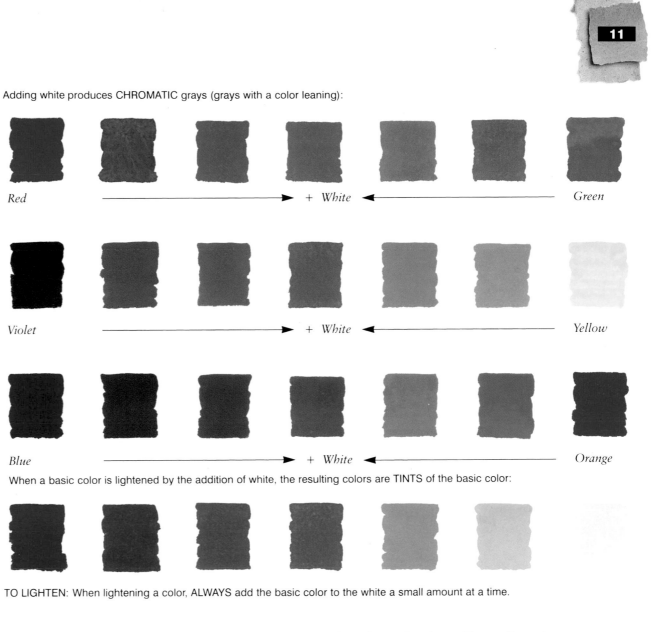

By mixing the primary colors, you get
SECONDARY colors:

Red + *Blue* = *VIOLET*

Blue + *Yellow* = *GREEN*

Yellow + *Red* = *ORANGE*

When SECONDARY colors are mixed, they
create a range of neutral colors:

Green + *Violet +* *Orange +*
Violet *Orange* *Green*

Adding white produces CHROMATIC grays (grays with a color leaning):

Red ——————————————→ + *White* ←—————————————— *Green*

Violet ——————————————→ + *White* ←—————————————— *Yellow*

Blue ——————————————→ + *White* ←—————————————— *Orange*

When a basic color is lightened by the addition of white, the resulting colors are TINTS of the basic color:

TO LIGHTEN: When lightening a color, ALWAYS add the basic color to the white a small amount at a time.

A basic color can be darkened by the addition of black or other darkening colors such as brown. The resulting colors are
SHADES of the basic color:

TO DARKEN: When darkening a color, ALWAYS add the darker color to the basic color a small amount at a time.

A minimal amount of equipment is needed for basic collage procedures; in most cases, general art and craft equipment is all that is required.

The essentials

An initial equipment list should include: All-purpose scissors; a craft (mat) knife; adhesive; water jar; paint palette; brushes; gloves; apron; ruler; cutting mat; pencils; and an eraser. In addition, cardboard and papers, and some method of providing color, such as crayons or paints, will be needed for the design stage. As you progress through the book, you will find that some of the more complicated processes require specialist tools or equipment. These are outlined in each section.

As you gradually invest in more equipment, you may find it useful to keep it all together in one place so that it is accessible every time you start work. Small plastic tool boxes are an ideal place to keep everything. They usually include compartments suitable for small items and can also accommodate some larger pieces of equipment. If you do not have a tool box, you could use small stackable boxes, or drawers labeled with the contents.

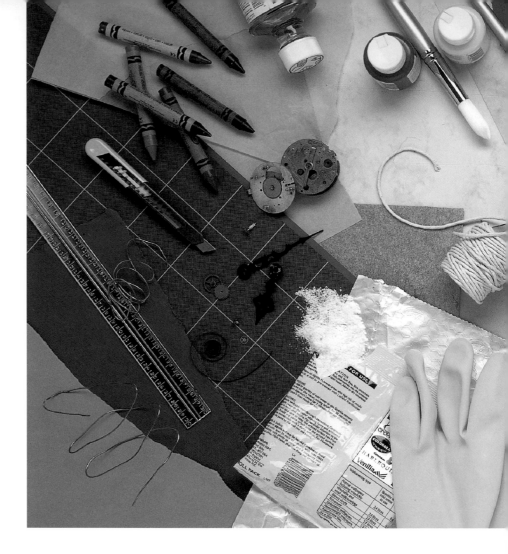

What's around – source material

For many people, the appeal of collage lies in the fact that the materials required are inexpensive and can be found in and around the home. With a little thought and time, a collection of useful source material can be gathered. There are no rules about what you can use, although you must consider how you will fasten objects together.

Before throwing anything away, think about whether it could have any use in your collage work. Discarded packaging, kitchen foil, plastic bags, gift wrapping paper, newspapers, string, and old garments can usually be found in most homes. Wires, small washers, bolts, and old watch parts also make interesting subject matter. Be prepared to rummage, and constantly bear in mind that you will normally need to attach objects securely to a background, so avoid heavy items.

Nature provides a treasure chest of material, but be careful not to damage living things and remember to take only a little from any source. When out and about on the beach, in a forest, or in your own yard, keep a lookout for colored leaves, fallen twigs, petals, flowers, bark, tiny pebbles, and shells.

LEFT: Collage can require a wide assortment of equipment and materials – a selection is shown in the picture: (clockwise from left) cutting utensils, coloring mediums and colored paper, newsprint, old fabrics, patterned paper, glues, pastes and rubber gloves. Fuller selections of materials needed for different types of collage are shown in each section of this book.

The natural color of an object can often be altered using paint, so don't reject an interestingly shaped item because you do not like the color.

Organizing your collection

Keep the things you find in bags or boxes. Wrap fragile items such as shells in tissue or cotton (cotton-wool) to help protect them. Your collection can be catagorized, which may help you when you come to select items to use. You could sort items according to where you found them, what you will use them for, or their size and color.

Whenever you work on your own collage, look at all of your collection for inspiration and lay objects or papers together to compare colors.

Caring for your equipment

A few simple procedures will help keep your equipment in good condition. Always remember to replace paint lids firmly to prevent the paint from drying out. When using paint brushes, never leave them standing in water; this will ruin the bristles. Wash brushes out thoroughly with warm water after using glue or paint.

Weaving paper.

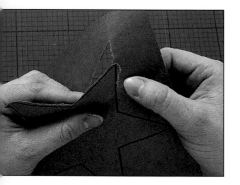

Tearing a shape.

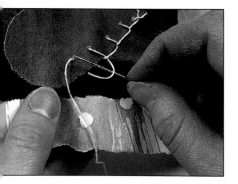

Stitching paper shapes.

Dealing with source material

Edge ideas

The choice of edge is important to the overall effect of the collage and will probably affect your decision of whether to rip or cut shapes and edges. Simple bold designs may look effective with straight cut lines, but you could perhaps also consider cutting some edges as zigzags. Consider tearing wavy and frayed edges in addition to straight ripped lines to add interest.

Ripped and cut edges

The two basic ways of creating shapes for collage are cutting and ripping. Cutting is more precise, offering a quick way of making complicated shapes and patterns. Most collage materials can be cut into the required shapes.

Ripping and tearing in a controlled fashion can create simple images, and with a little practice you can gain more control over the resulting shapes.

Grain

Papers, photos, computer images and découpage source material can all be torn with or against the grain. It is slightly harder to work against the grain and requires more control to produce definite shapes. If a "straighter" edge is needed, you must tear along the grain. To discover which way the grain lies, cut a square of your chosen paper and boldly rip it from top to bottom. If the line is difficult to rip and appears wobbly and frayed, you have just ripped against the grain. If the line is fairly straight and clean, you have ripped along the grain.

Chamfered paper edges

When white painted paper is ripped, one edge will show the white paper base, whereas the other will show only the painted, colored edge. The edge which shows the white

paper base, called the chamfered edge, can be used to great advantage in collage. Shapes outlined by the chamfered edge will stand out from the other collage shapes, even if they are the same or a similar color.

Mixing textures

Collages incorporating a variety of textures can be striking. Consider placing shiny objects such as metals alongside matte papers and contrasting layers of natural objects with manufactured items. By experimenting with as many textures as possible you will become familiar with the properties and surfaces of different objects.

Light and layers

Light can be used more effectively in collage with surfaces that have been manipulated than with flat surfaces. For example: curled strips of paper cast dark shadows, crinkled foils will bounce light and cast shadow. Consider curling the edges of leaves, using pleated transparent fabrics with layers of crinkled colored paper underneath or fraying the outermost edges of photos.

SAFETY FIRST

Cutting can be done with scissors or a craft (or mat) knife. Scissors are easier to handle, but may not allow the degree of accuracy afforded by a knife blade. Always keep your fingers clear of the blades of scissors or knives and cut slowly, with care and attention.

The composition of your work – where you place each paper shape and pattern – is crucial to the overall effect of the finished work.

Composition

The planning stage, which will help you to visualize the finished work in a rough format, is an important part of the process. Use the tips in the sketchbook section to help you sketch out your ideas, making a note of colors and sizes and the placement of each element of your picture before you start. This should be seen as a guideline and not stuck to rigidly. Don't be afraid to change your mind as work progresses.

Linking and integrating

Disjointed areas can appear when simple bold shapes are used. Spaces between the shapes can often appear empty and need added interest. Scattered pattern is an effective way in which to break up any such empty space.

By using objects with similarities of shape, color, and tone throughout a piece, you can link disparate areas and create an integrated whole. Think about how the background will interact with the elements you are placing over it. You can emphasize parts of it by using objects with a similar shape or texture; real leaves over an image of foliage, for instance, or a row of regularly spaced buttons sewn on to a spotted fabric background.

Ask yourself questions about various aspects of the composition as you are working on it. Does a large plain area need to be broken up with smaller objects or overlapped by another shape? Do detailed areas need to be separated by a contrasting color or flat shape? Does color or tone need to be added to part of the collage to balance a similar color or tone in another area?

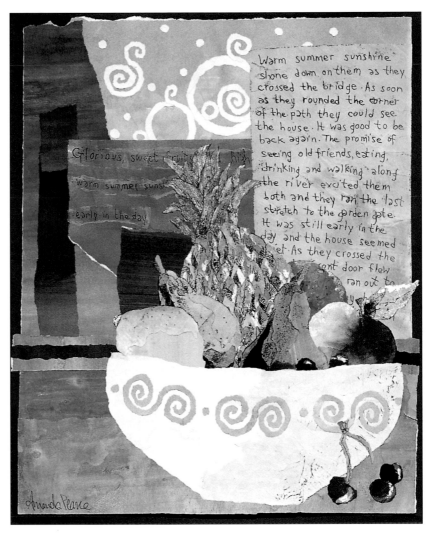

Amanda Pearce

Sweet Fruits

Large areas of flat color may need integrating into the picture. Here empty spaces have been broken up by delicate swirls and dots, echoing the pattern on the fruit bowl, while the addition of blocks of text balances the detailed black ink work in the fruit.

Assessment of work in progress

It is important to assess your work constantly as it progresses. Do not be afraid to discard shapes and elements that are not working. For example, if a particular colored shape draws attention away from the rest of the work, remove it and see what the result is. You can always put it back in place if you decide it looks right after all.

An important element of collage work is to reposition the individual elements as many times as necessary until you achieve the effect you want. If an area doesn't look right, remove some of the shapes and make them again. If a pattern doesn't sit well, lift it off and place it in another area of the collage. Accidental discoveries made by arranging and rearranging objects in this way are very exciting and can be exploited when considering the composition of a collage. Also think about the structure of your collage; it can be representational or abstract, objects can be arranged randomly or symmetrically, and it can be as simple or as complex as you like. Sometimes taking a break from a piece of work can make a difference. After a few hours away, the problem area "jumps out" and can be corrected immediately.

Color

Careful use of color can help balance a design. It is wise not to have a picture made only of dark or light colors. A dark piece of work could look overpowering and can be lightened considerably if hints of a lighter color are added. The contrast between light and dark colors is so effective that the new pattern will not diminish the effect of the dark colors, but will enhance them.

Having too much or too little of one particular color may throw off the balance of the finished work. If a color appears as a large shape or single area, use a little of it somewhere else in the work. Black will often overpower a composition, so it should be used sparingly and with great care. White can be effective, although a picture can be enhanced even more if paler versions of colors are used.

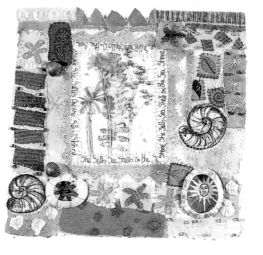

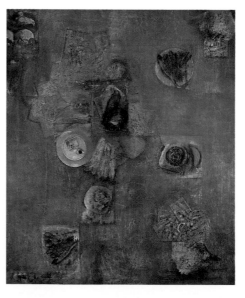

Rachel Griffin
Beach Combing

Repeated use of a shape or motif can be used to give a structure to the final composition. This fabric and found-objects collage makes use of lines of circular and rectangular motifs to pull together a patchwork of colors and images.

Joanne Soroka
Three Kimonos

The addition of flecks of grays and blacks to this image of pale white kimonos adds texture and avoids the picture losing definition. The folded Japanese paper kimonos create shadows in the work which also help to balance the darker tones of the flecks.

Brian Ord and Val Close
The Deep

You do not need a large palette of colors for work to be successful. Consider making use of different shades and tones of one or two colors. This piece combines a variety of reds with blacks and charcoal grays to produce a stunning mixed-media collage.

Jim Harter

The Mythic Sea

This work makes use of a variety of different scales. The figure has been enlarged to tower over the smaller landscape, while the dark sky area has been broken up by a host of tiny scattered stars. The final effect is both dramatic and dream-like.

Keith E. Lo Bue

My Trembling Soul

The edges of collage work are as important as the main elements. Here the artist has layered torn freehand edged papers over a structured rectangular brooch. The ends of the stick pin and the distressed gold leaf all add to the antiquated feel of the work.

Balance and scale

Scale of shapes and pattern plays an important part in a balanced piece of work. If everything is the same scale, the picture may look lifeless and static. The addition of pattern or shape of a different scale will add movement and interest.

One of the most versatile aspects of collage is the way in which images can be manipulated in size. Photocopiers allow découpage and photomontage artists to make quick changes to the size of an image. Work can be scaled up and down, stretched, reversed, and repeated.

Computer images can be manipulated in size while fabrics and papers can easily be cut to fit any scale.

Whatever scale you choose to use, always work to produce a balanced final piece.

Every time you move, add, or remove something, the balance of the piece will be affected, so wait until you are sure about the placing of an object before gluing it in position.

Final touches

The edge of the work is as important as the content. Different treatment of the edges will lead to different results. A formal approach might demand neat straight edges, whereas collage with a handmade appeal such as a fabric picture might work better with rough, frayed edges.

Deciding on the color and type of mounting for a collage is a very personal matter, but obviously the decision should bear some relationship to the style, size, and color of the work.

Collages containing three-dimensional objects can be framed in a similar way to ordinary pictures, but will obviously need a molding with a deeper recess than normal, and strips of wood inserted to hold the glass away from the raised surface.

More three-dimensional collage work should be sealed with several layers of varnish before it is used. Otherwise, the paper may peel at the edges and become worn.

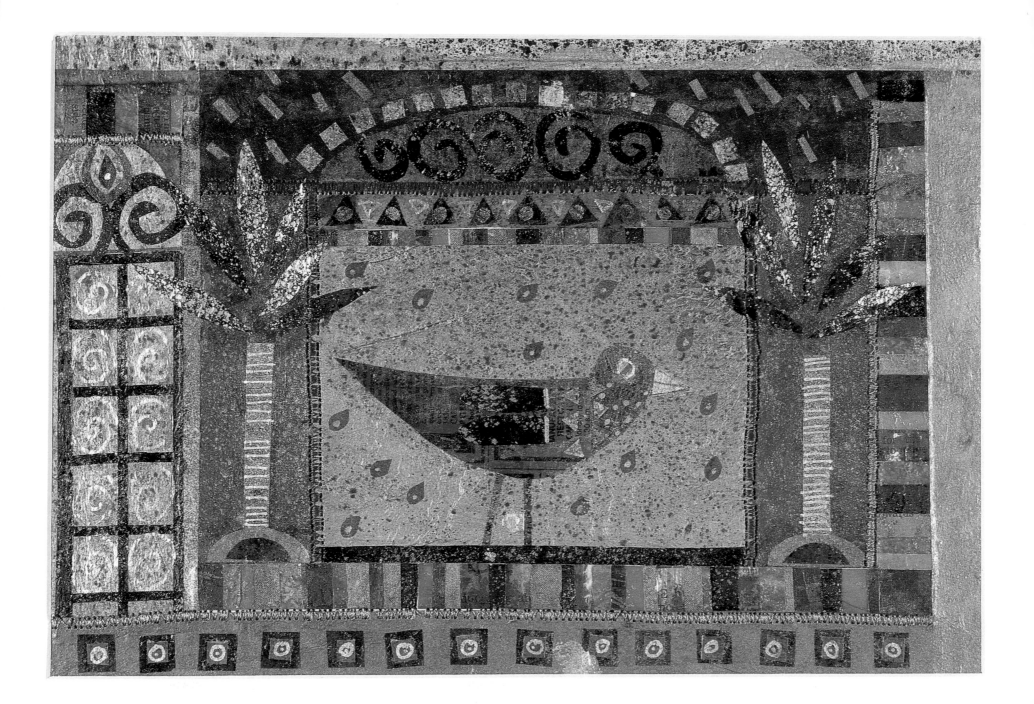

The versatility of paper collage rests in the fact that each piece of paper work is unique. Even if colors and imagery are repeated, the likelihood of any ripped or cut edge looking the same twice is remote.

Paper Collage

The choice of papers is important. The type, weight, and appearance of the papers can drastically alter the effect of the finished work. When choosing paper, consider the thickness, transparency, surface texture, and durability. As a general rule, heavy, textured paper will lead to bold effects, whereas thinner, transparent papers will give your work a lighter, more delicate feel.

Once you have chosen the papers, you can achieve a wide variety of effects by varying the way in which you use them to make shapes and patterns. Combine both cut and ripped edges to alter the feel of your work. Instead of using flat shapes, curl, pleat, and fold paper for a variety of results.

By adding texture to the papers you use, your work can become more sophisticated. Plain paper which has been hand-painted and stenciled adds an individual touch to your work. The following section gives you the information needed to create individual paper collage work. Clear, practical suggestions on techniques guide you through the wide variety of papers available, help you to explore a variety of creative possibilities, and offer expert tips as you experiment with color, texture, and composition.

The choice of papers is the important first step of paper collage that must be given some thought. The use of different papers plays an important part in creating various moods for your work.

Materials and properties

Color of paper is usually seen as the first consideration. However, since color can be added later, the weight and texture of the paper can actually be more important. A stiff handmade paper may have flowers in the design, but could be more difficult to rip and may need to be cut. This would create crisp lines and perhaps overpower the delicate lines of the petals. Thin paper rips easily and may be too frail to tear into small shapes. The most appropriate choice of materials can be made when these points have been taken into consideration.

When gathering papers for collage, lay them together to assess the colors, textures, and weights. Try cutting and tearing edges, then overlap areas to test the effects.

quality

Consideration must also be given to the quality of paper to be used. It may sometimes be necessary to use durable, tough paper – for example, if the work will be on display and can be touched. However, if, for example, a work will be framed, more delicate papers can be used. A special gift might be better made from high-quality paper to make sure it lasts, whereas a quick children's project could use readily available and inexpensive paper such as newsprint as the basis for the work.

paper weights

The weight of the paper can be as important in creating a mood or feel as the surface texture. Layers of fine, transparent paper will create a delicate effect; heavier corrugated cardboard and brown paper would give a more functional, industrial feel to a collage.

Remember that the simpler the imagery, the more imaginative you can be with the use of various papers. A piece of work can become busy and overcrowded if it includes lots of different types of paper.

paper age

Old sheet music, faded newspapers, and sun-scorched brown paper can all give a collage an aged appeal – creating the illusion that the work was completed a long time ago. Contemporary shiny, metallic papers and computer paper lend a modern, futuristic feel to a piece of work.

experimenting with papers

A versatile medium, paper can be creased, crinkled, crushed, pleated, and curled. By using a variety of manipulating techniques, you can alter both the general appearance and surface quality of paper.

Try a variety of these techniques with one type of paper. Remember that, if paper has been constantly creased and crinkled, it may start to wear. This quality could be used to your advantage to create a distressed, old feel.

surface texture

The surface texture of paper is how it feels to the touch. Some papers are smooth and shiny, while others are rough and grainy. The best type of paper to use will depend on how you want to use it. If you want to add extra texture and color yourself, the mediums you choose to do so could be affected by the surface of the paper. For example, paint takes best to paper with a slight texture. If the paper is too shiny, it will repel the liquid and the paint will not cover the surface very well. Textured paper such as recycled or Ingres paper is ideal for pastel and crayons.

Using paint to create your own "surface" on store-bought papers requires only a few simple tools and is easily done. Preparing your own papers will add a personal touch to your work, and allows a greater choice of colors, textures, and surface finishes.

Painted textures

Any type of paint may be used including watercolor, oil, acrylic, gouache (opaque water-color), or poster paint. Acrylic will give a flat surface, whereas watercolor can be used for a very subtle and watery paint surface. Oil paint can be applied in a thicker consistency for a textured effect. Gouache can be used in the same way as watercolor, but allows for a richer, more opaque color if required.

The method you use to apply paint to the paper will alter the overall effect of your work. Applying the color with different-sized paint brushes will add interest to the paper and give a variety of brush marks. Try a wide decorator's brush or an old toothbrush, as well as standard painting brushes. In addition to basic brushes, a great many household objects can be used to apply color to paper. Try using old rags, combs, even your fingers.

Vary the strength of the paint and amount of water used when mixing the paint. Thick paint with a small amount of water will give a dark and textured effect, whereas thinner paint using lots of water will create a pale and watery effect.

Stretching paper

Stretched paper retains a flat shape even when watery paint is used, while paper which has not been stretched will crinkle after the paint has dried.

1 Cut one length of brown paper tape (kraft) for each side of the paper. Each one needs to be slightly longer than the paper edge.

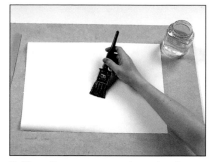

2 Place the paper on a clean drawing board. Using a wide painting brush, thoroughly wet the paper with bold strokes. Do not keep going over the same area of paper.

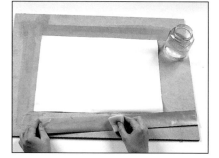

3 Wet a household sponge and apply it to the shiny adhesive side of one length of the brown tape. Place the wet tape along the side of the paper so that it overlaps both the paper and the board. Repeat the process for both sides of the paper. Use a damp sponge to gently remove any creases that occur. Leave the board on a flat surface to dry before using the paper.

TIP

When the stretched paper is fully dry, you can use it to paint on. Painted stretched paper has the advantage of not curling and crinkling when paint is applied. To remove painted paper from the board, carefully score using a craft knife and ruler along the brown paper tape, cutting the very edge of your painted paper. Trim the surplus brown tape from your paper with a craft (mat) knife.

Graduated paint effects

Graduated paint effects can be achieved by increasing the amount of water used as you paint a sheet of paper. Start with thick watercolor paint (a little water and lots of pigment) and as you fill the page, add more water to the mixed paint. This will make the last area painted very watery and much paler than the first section painted. This effect can also be used to graduate from one color to another. Mix two colors – for example, orange and red. Begin by painting the orange. When you have painted half of the paper, add some red paint and merge the two colors together using water. Continue by painting pure red at the bottom of the paper.

Have a jar of clean water at hand when mixing paint colors. Change the water regularly to keep the colors clean.

Graduated paint effect with one color

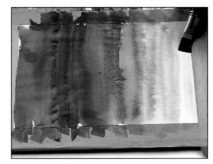 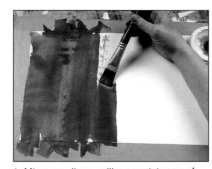

1 Mix a medium, milky consistency of paint. Using a broad brush, paint in bold strokes across the paper. If the paint does not cover well at this stage, add a little more water.

2 Add more water to the paint as you paint farther down the paper. Merge the bolder color and more watery paint by sweeping your brush several times across the seam where the colors meet.

Graduated paint effect with changing colors

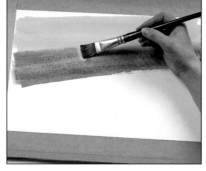 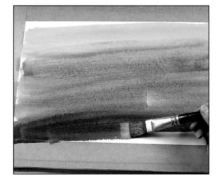

1 Mix three colors of paint which will blend well together, for example, red, orange, and yellow. Paint one third of the paper with the yellow as described in step 1 above.

2 Now paint the next third of the paper orange, starting by overlapping the two colors, then continuing below the yellow. Use a damp brush to conceal the seam between colors.

3 Continue by painting the remainder of the paper red, once again using a damp brush to conceal the change of color.

TIPS

ABOVE: Remove excess water from your paper using a rag or piece of paper towel.

When using brushes, remember to wash them out thoroughly after use.

Never leave a brush standing in a jar as this will ruin the bristles.

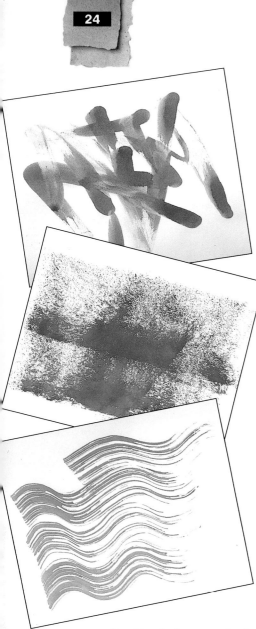

A variety of other textured paint effects can be achieved by painting with your fingers, using a foam roller dipped in paint, and swirling with a paint-covered comb.

Brush marks

How much water you use when painting these brush marks will also alter their effect. Using very little water will encourage definite brush marks; adding lots of water evens out the brush marks and creates a watery effect. The technique below is an exercise to show both how to make definite brush marks and how to eliminate them.

Disappearing brush marks

1 Using a creamy consistency of paint paint bold strokes from side to side across a sheet of paper. The brush should be damp enough to carry paint across the page and leave definite marks.

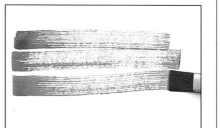

2 Add a little water to the paint and wet the brush thoroughly. Starting at the top of the page, sweep the brush over the paint several times. The now-watery paint should eliminate the dry brush-marked areas.

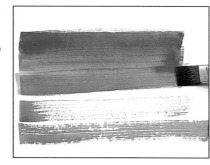

3 The paint can be left with areas of brush marks, or it can all be painted over to produce a softer, more watery effect.

Marbling

Oil-based marbling inks, available from most art and craft suppliers, can create a variety of stunning effects on paper, making it an ideal technique for preparing collage papers. Before starting, place a clean piece of paper on the water to remove any debris and dust from the surface. Remove the paper and slowly add drops of colored inks to the tray.

1 Fill a deep tray with about 3½ inches (8 cm) of water and place on newspaper or scrap paper. Place a sheet of plain paper onto the surface of the water to catch any debris and clean the surface.

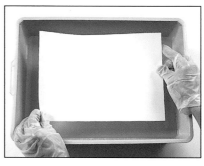

4 Place a clean sheet of paper carefully on the surface of the inky water. Leave it in place until you start to see the pale ink image coming through to the back of the paper.

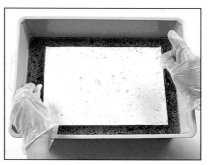

RIGHT: With a little practice, marbling can result in some stunning effects. Try using paper which you have painted different colors.

Use the end of a paint brush or an old comb to swirl the paint around on the water surface. If you use more than one ink, the colors will mix together. Once you have distributed the colors, place a clean sheet of paper on the water.

Once you see the inks starting to appear on the top of the paper, then carefully lift the paper from one end.

Taking several prints from one run will make the results gradually weaker. Try using prepainted paper, or varying the concentration of inks in one area of the tray.

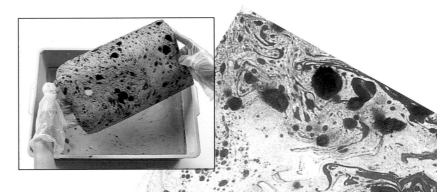

How to achieve a marbled effect

2 Wearing gloves, hold your ink bottle above the tray of water and slowly drop ink onto the water surface. Add drops of a second color ink. You can use as many colors as you like at one time.

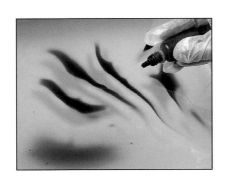

3 Use the end of an old paint brush or an old comb to swirl the inks around on the surface of the water.

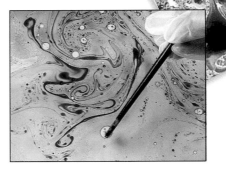

5 Carefully lift the marbled paper up from one side.

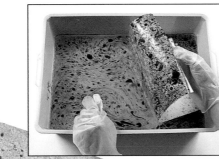

6 Hold the marbled paper above the water to let the surplus water run into the tray. Place it on newspaper to dry.

Repeat steps 4–6 with a fresh piece of paper. The result will be a paler image.

Painting a freestyle pattern

Another simple way to make a repeat pattern is by painting shapes freestyle. Paint a shape using a contrasting color to the background. Either use the finished sheet of pattern as it is, or rip each shape out individually and then place it on another sheet of prepared paper.

Create a freestyle pattern

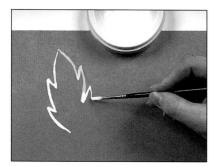

1 Decide on a simple motif and consider the size you want it to be in your finished pattern. Mix paint to a milky consistency and paint your chosen shape at intervals on textured paper.

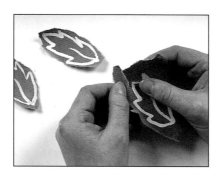

2 When the paint is dry, rip or cut out the individual shapes.

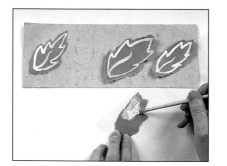

3 Arrange the shapes on a different color or type of paper, apply glue to the back of each shape, and stick in place.

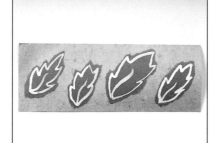

4 The finished sample shows how the scale of each shape can be changed easily when painting freestyle. The torn or cutout shapes could be used for a background or border.

Repeat pattern

Repeated patterns work particularly well in collage. Sheets of pattern can be used as backgrounds or can be torn to leave fragmented pieces.

One of the easiest ways to create random pattern is by using a potato as a printing block.

Repeating a pattern: Potato printing

1 Carefully cut a large potato in half. Press the cut edge on paper towel to remove any excess moisture. Using a craft knife, carefully cut a simple shaped design into the cut edge of the potato. The design must have a flat surface so that it prints evenly. Cut away any excess potato from around the shape.

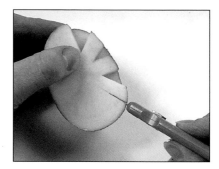

2 Mix some paint to a smooth, thick consistency. Use a sponge to cover the potato shape with paint. Test the potato print on scrap paper first. Press the painted potato firmly down onto the paper. Be careful not to move it around; this will smudge the image.

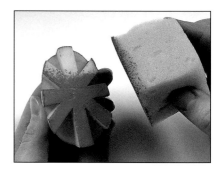

3 When printing the repeat pattern, keep applying fresh paint to the potato shape. You could sketch where you want to place the printed images on scrap paper before you start.

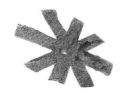

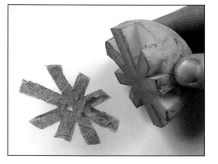

Carefully cut a potato in half. Cut a design into the surface of the potato, making sure you have cut away all unwanted areas. Mix some paint to a fairly thick consistency and apply it to the potato using a sponge. Test the print on scrap paper. Print randomly across the page. When the print is dry, you could print a second time using another color.

Different textured finishes: Toothbrush

1 Paint a sheet of paper with a base color. Mix a watery consistency of paint. Dip an old toothbrush in the paint, and pointing it away from you, hold the toothbrush over the painted paper. Use your forefinger to flick or splash paint marks over the colored background. You could mix another color and splash it on in the same way.

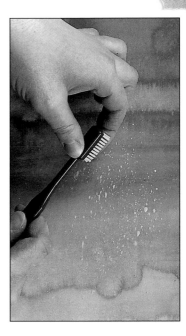

Consider the choice of paper for your background. Excellent effects can be achieved by printing onto foil, clear acetate, construction paper, and tracing paper.

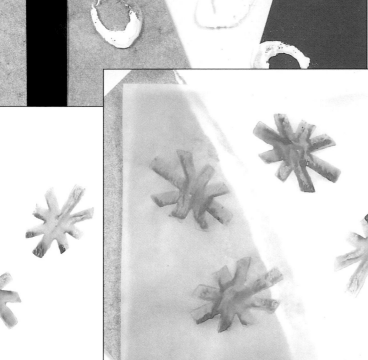

2 A slightly bolder effect can be achieved by firmly flicking the whole toothbrush downward while you hold it over the paper.

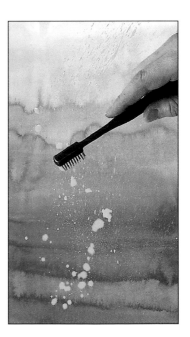

Applying color to black and white surfaces is one way of lending a more personal approach to your collage work. Ordinary everyday images can be transformed into more personal elements ready for use in collages. Your choice of colors will reflect your own style much more than store-bought papers and materials.

Adding Color

The choice of colors for applying onto black-and-white images will depend on the subject matter of that image. Before using any colors, experiment until you find a combination that you think fits the image. Consider whether you would like the colored image to be realistic. An unexpected color palette can result in highly original finished work. Other mediums can be used to color black-and-white images. Try experimenting with chalk pastel on newsprint, oil pastel on photocopies and fiber-tipped pens on photographs.

Adding color to black-and-white: Newsprint

Some of the most effective collages can be worked using very simple images and the most ordinary papers. One of the most readily available papers is newsprint. It can be used as it is, or livened up by applying color over the print.

Consider whether to use a page with text, figures, or photographs and choose a sheet of newsprint. It might help to try to imagine what the page would look like fragmented. Use a medium-consistency paint and apply it boldly over the newspaper. Vary the amount of water used and leave some areas free of paint. The sheet can be used as it is as a background, or it can be fragmented and ripped into the shapes for a collage.

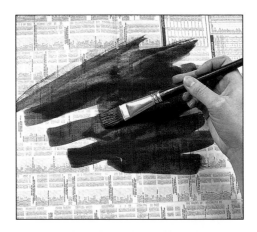

1 Flatten out a sheet of newspaper. Mix paint to a medium milky consistency. Using a flat brush and broad sweeping strokes, cover the newspaper with paint.

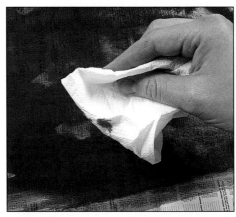

2 Leave some areas free of paint, and completely cover other areas. Agitate the newsprint, turning it gently from side to side, to alter the effect of the paint.

Blot the newsprint with paper towel to remove excess water and leave an interesting texture on the surface.

3 Rip patterns and strips from the painted newspaper. Ignore the text and images, using them purely as a textural effect.

28

Adding color to black-and-white: Photocopied sketches

This process also works well with old sheet music and your own sketches.

To use your own sketch, take a black-and-white photocopy. Lightly sand the surface to remove the gloss finish, then apply paint. The artist has here outlined the subject, but you could also cover the whole sketch.

How to color photocopied sketches

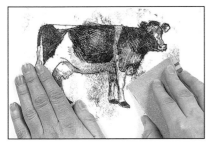

1 Using good-quality black-and-white photocopies of your own sketch, lightly sand the surface using fine sandpaper.

2 Mix a watery consistency of paint and start to outline your sketch. Finish the paintwork by covering an area of the background to make it look as if your subject was originally drawn on a colored background.

3 On the finished image, the unpainted edges of the photocopy have been ripped away.

4 You could try painting strange colors over a whole photocopy to give the whole image a quirky effect.

Adding color to black-and-white: Photocopied photographs

Take black-and-white photocopies of your own photographs, making enlargements and reductions to the size required. Trim the edges and decide on a layout for your collage. Try using tracing paper and transparent acetates with the photocopies as they look effective together. Paint areas of tracing paper, then trim and make layers with the photocopies.

photographs

1 Photocopy photos of interesting architecture, making some enlargements and reductions.

2 Trim the edges of the photocopies. Some of the images can be cut into interesting shapes at this stage.

3 Mix a watery consistency of paint in a light color. Cover an area of semitransparent tracing paper with watery paint and let it dry. Trim the tracing paper so that no unpainted edges remain.

4 Layer the tracing paper, photocopies, and some colored acetate to make a finished collage.

A variety of different effects can be achieved with paper collage to create accurate and realistic images. Working directly from subject matter in front of you will make your interpretation of the shapes and colors much more accurate.

Painted paper collage

Start by painting white paper with the colors you require. If you prefer, you can use store-bought papers which are already colored. Use a good quality paper as a base for the painted colors, so that the paper doesn't warp. Once the colors you have painted have dried, tear the main background and bowl shapes. Then make the fruit and add pattern to the bowl.

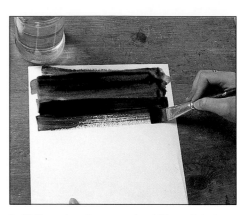

1 All the colored papers should be painted prior to starting the collage. Paint separate flat areas of color in prussian blue, lemon yellow, purple madder and naples yellow mixed with white. Don't worry about the uneven marks in the watercolor washes as it adds to the charm. Leave the papers to dry.

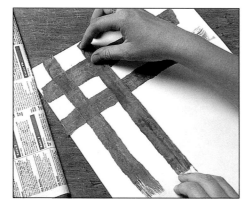

3 Tear the tissue paper along the grain (see page 14) with long, easy strokes, into strips about ½ inch (12 mm) wide. To make a checked tablecloth, place 3 of the strips in horizontal rows about 1 inch (25 mm) apart. Fix into position with white craft glue (PVA) then fix the remaining strips vertically.

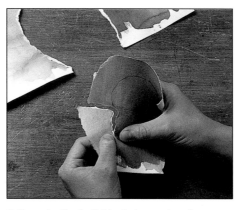

4 To make the individual shapes tear the colored papers into managable pieces. Sketch an outline of the shapes onto the papers. Start tearing just inside the pencil lines. Consider whether you want the white chamfered edge to show (see page 14). Tear with short, precise movements.

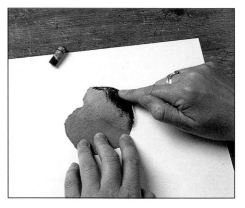

5 Adding colors and tones to shapes is achieved by drawing and smudging pastel on the torn paper pieces. Here, the blush of an apple is applied with an alizarin crimson pastel softened by rubbing the marks with a finger.

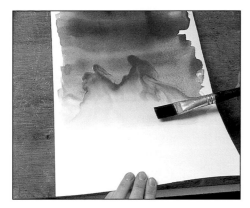

2 Using sap green, paint a sheet of paper with a distinctly graduated wash (see page 23). Areas from this will be used to create the light and dark tones of the pears. Paint one sheet of tissue paper with sap green. Leave both to dry.

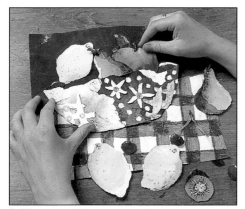

6 It is a good idea to assemble the background first, the arrangement of fruit next, and finally the bowl. You can still keep adjusting and tearing the shapes as you position and glue the pieces. When gluing, apply glue to the reverse side of each piece, rather than the background.

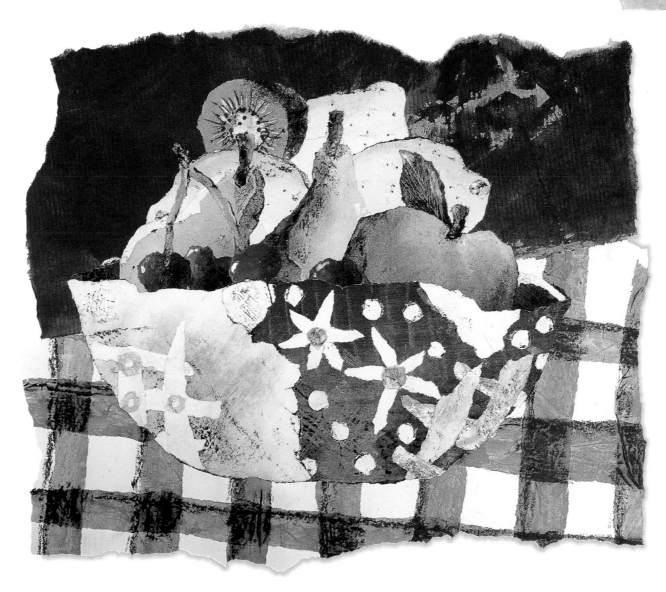

Wendy's Bowl

a m a n d a p e a r c e

Handmade greeting cards will be appreciated long after purchased cards have been discarded. Putting time and effort into a card for a friend's birthday, to celebrate a wedding, or just to send best wishes is rewarding and fun.

Greeting card

Cut a piece of thick paper so that when it is folded, it fits into an envelope. For the collage image itself, you could use either precolored papers, or paint your own.

First tear the background shapes, then make the patterns and flower petals. If you are adding a name or greeting, make it at this point and decide where it will fit. Assemble the flower, then glue all of the component parts in place, starting with the background and working up.

1 Cut a piece of thick cream or white colored paper 6 × 8 inches (15 × 21 cm). Mark where the middle is and carefully score down the center using a pair of scissors.

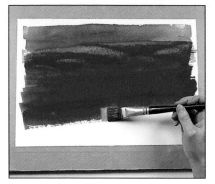

2 For the main background, paint a graduated wash of red and orange (mixed from yellow and red). Paint more sheets of paper using yellow, cobalt blue, turquoise blue, lime green, and cream.

5 Tear out approximately 13 yellow petals for the flower, making each one similar in size.

6 Tear the wavy cobalt blue border shapes, cream dots, and a spiral for the middle of the flower. You can draw the shapes with a pencil first to help make them more accurate, but remember to erase any pencil lines.

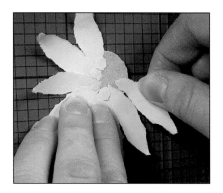

7 Glue the end of each flower petal on the back. Assemble the flower by gluing the edge of the petals onto a green central circle. Place each one equidistant from the last.

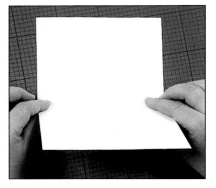

3 Fold the card along the scored line and check that it will fit easily into your envelope. This card fits into an envelope approximately 4½ × 6¼ inches (11.5 × 16 cm).

4 Tear or cut the background rectangles from turquoise, red/ orange, and lime green papers. Make sure they will all fit onto your folded card and still leave a slight border area.

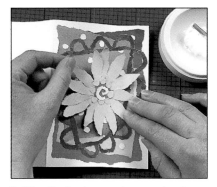

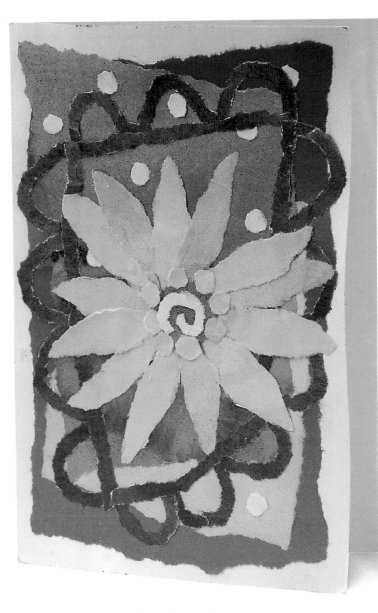

8 Glue the background rectangles first, followed by the wavy blue borders, white dots, and finally the flower.

9 A simple motif can be made for the back from leftover bits of colored paper. Glue it firmly in the center of the back.

Greeting card

amanda pearce

The scope of collage with paper is apparent in this collection of work by four contemporary artists, which shows several techniques including ripped and cut edges, layering, and textured paint surfaces. A variety of papers have been used – each creating different effects in the finished work.

Gallery

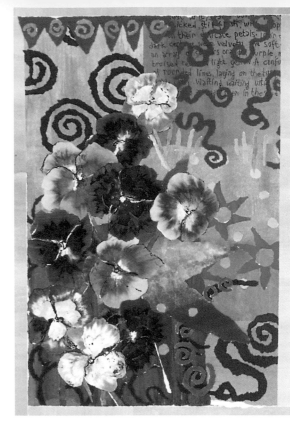

Amanda Pearce

Soft Petalled Pansies

Paper collage lends itself to work of a decorative nature. This busy design layers stenciled motifs and patterns torn freehand over blocks of handpainted paper. The end result is a richly colored background for the paper pansies.

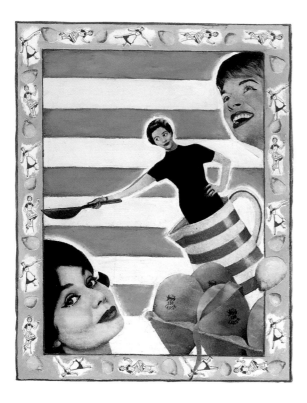

Melanie Barnes

Pancake Day

Inspired by 1950s domesticity this piece uses an exciting combination of techniques – magazine cutouts have been laid onto handpainted stripes. In some areas, the edges of the cutouts have not been firmly stuck down, creating shadows giving the work a more realistic effect.

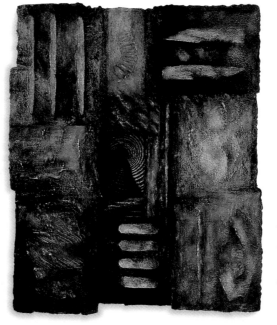

Henrietta Hine

Destination

Handmade paper has been embedded with natural objects then painted with earth pigments. The resulting papers are partially gilded and layered together, the frayed edges creating a subtle and natural edge to the work.

Julie Morgan

Blackbirds & Vase

Inspired by ethnic cultures and artefacts, this delicate paper collage combines blocks of handmade paper with sheet music and touches of gold paint. The artist has added textured finishes to the paper by scratching into the acrylic painted surface.

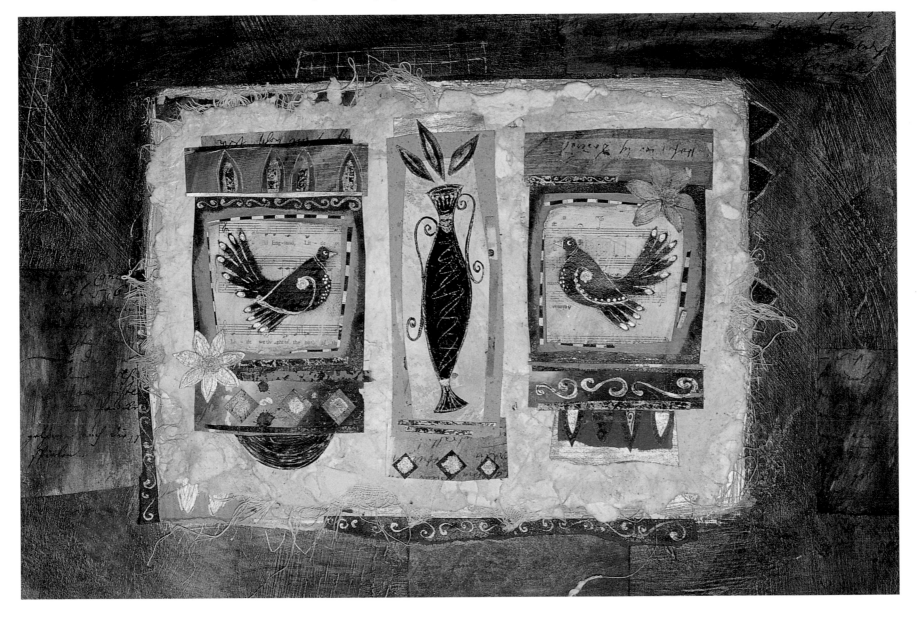

The exciting thing about making collages with found objects is that there is such a wide variety of material to choose from; the creative possibilities are limitless.

Found Objects

One of the greatest pleasures is recognizing the potential of things you see around you every day and building a collection of material that can be used in a collage. This material may be found in the countryside, the garden, the street, the beach, or the home; wherever you are, there will be objects to discover and collect.

Collecting objects and recycling them can be creative in itself. It is very satisfying to know that a discarded radio or clock can be taken apart and its components used in making new and exciting objects. When friends and relatives know what you are doing, they will often share your enthusiasm and bring you envelopes or boxes of bits and pieces that they have discovered themselves.

The following section will give you some ideas about how to use the objects you have gathered, with hints on techniques and composition. It will also help you to explore and experiment with a variety of material so that you can create a found-object collage for yourself.

The great fun of found-object collage is that you can be walking through a street or in the country and, by using your imagination and powers of observation, you can collect items that may inspire some of your best work.

Materials and properties

You should get into the habit of carrying clean bags or small boxes and tissue paper with you as often as possible so that you can keep interesting objects together and safe until you can return home and add your "treasures" to your collection.

Altering objects

Found items can be used as they are or altered to create new and unique shapes; shells, bones, circuit boards, and brittle objects can be broken with pliers; paper can be cut, torn, crumpled, and folded; dried leaves and fabrics can also be cut or torn to almost any shape.

texture

All materials have a characteristic surface; it may be smooth, ridged, hard, soft, irregular, patterned, coarse, or fine. Be aware of the variety of textures that are available when working on a found-object collage. Use objects that already have an interesting texture, such as leaves, bark, and shells. Or you may want to create textures for yourself using sand, seeds, and threads.

manufactured objects

Before throwing out broken electrical items, take them apart to see what is worth saving for your collection. Clocks and watches also contain many intricate parts that can be removed.

Whether in the street or home, look out for watch parts, circuit boards and electrical components, wire, washers, nuts and bolts, wire mesh, lace and other fabrics, thread, buttons, parts of models and toys, beads, coins, and jewelry.

natural objects

The countryside, beaches, and gardens contain a rich supply of natural material for the collector of found objects. Remember to take plastic bags or pots with you when you go walking; they are essential to keep your finds safe until you get home.

You could collect berries and seed skeletons, dried flowers, bark, lichen, shells, and feathers.

transparency

Semitransparent items allow varying amounts of the background to show through. Overlaying such material as leaf skeletons, lace, wire mesh, and tissue paper will add richness and depth to a collage. They will also change the background texture, color, and tone and enliven large dull sections and break up divisions between areas.

color and tone

By using the color and tone of the objects in your collection, you can produce a wide variety of effects. Light objects show up more clearly on a dark ground and dark objects on a light ground. But for more subtle effects, experiment with using objects of a similar tone but different color; red berries on a dark green suface, for instance.

The harshness of metallic objects can be subdued when used with warm reds and oranges.

Magazines and books contain images which can be used as exciting backgrounds. If you do not want to damage a book, make photocopies of approriate sections; this also allows you to use multiples of the same image. You should take care concerning copyright laws.

Look out for maps, photographs, newspapers, postcards, wrapping paper, letters, stamps, labels, tickets, foreign banknotes, sheet music, and cellophane wrappers.

The most important part of any collage is the planning stage. Once you have your ideas finalized, you are ready to alter and prepare your materials so that you can work to your plan.

Preparation and altering objects

When you begin a found-object collage, it is a good idea to apply the material to a sturdy surface. You can work straight onto stretched paper (see page 22), but you may find that the finished piece will not remain flat because the layering process and the amount of glue used to hold the objects in place creates tensions in the paper which pull in different directions and cause the paper to curl. If you choose a thick board as a sturdy backing, this problem can be avoided. Cut the board to the size you want to work on, apply glue to one side, and place it in the center of your stretched paper. At this point you may need to apply some pressure to the board to make sure it adheres; a heavy book or two will hold it down. The stretched paper will buckle slightly, but it will flatten again when the glue has dried. White craft glue (PVA) is very versatile and can be used to attach paper as well as larger objects; it dries transparent and, when used undiluted, is very strong. However, there may be times if you are using metallic or plastic objects with a smooth surface when a stronger adhesive such as epoxy resin will be more appropriate.

Preparing a background

The next stage of making a collage is to cover the board and create a basic surface onto which other material can be added. By tearing or cutting areas from magazines, wrapping paper, maps, and so on, and gluing them to the board, you can quickly build up a base of contrasting color,

tones, and textures. Alternatively, you may want to work on a very simple base, perhaps a single flat color or one with little variation in color or tone. Think about composition and whether you want your collage to be symmetrical or random, but also remember that this is only a background and you can alter it by adding more material. Also consider that you may want parts of the background to show through if you add semitransparent material.

Creating a background

1 Apply glue to a piece of thick cardboard about 4¾ × 8½ inches (12 × 22 cm). Make sure the whole surface is covered.

2 Place the cardboard in the center of your stretched paper. You may need to weigh it down with a book or two until the glue has dried.

3 Apply the material you have selected for your background with craft glue. Remember that at this stage glued-down areas can easily be covered if you change your mind before you start building up more three-dimensional textures.

4 Consider the color and tone of both the object you are using and the background on which it is to be placed. For example, a red petal contrasts when placed over a black-and-white surface or a white shell shows up clearly when placed on dark blue.

Overlaying

Once your background is complete, there is a variety of materials which can be added to build up rich surface textures. Semitransparent objects such as leaf skeletons, thin fabrics, or tissue paper provide delicate surfaces where the background shows through. Other textures can be created by applying glue to a particular area and sprinkling sand, seeds, or even glitter over it. When the glue has dried, brush away the particles that have not stuck, and again parts of the background will be visible.

If you apply linseed oil to paper, it is also possible to create your own semitransparent material. Choose an image that interests you, perhaps a black-and-white photocopy or something cut from a magazine, and brush oil onto the surface. It will immediately soak into the paper, which will then become semitransparent. Remove the excess oil with a clean cloth or paper towel, glue the reverse side, and apply it to part of your collage. If you choose an area where the background contains contrasts between dark and light, the effect of its showing through will be clearer. You can also add subtle color to black-and-white images. Brush a small amount of oil paint and a little linseed oil on the paper wherever you want the color, and then clean off the excess with a cloth or a paper towel.

Small opaque petals and leaves can be spaced so that some of the background is visible, or overlapped so that the background is covered, creating a textured area. You may decide that you want to use larger objects at this point. This is where you can experiment by placing objects on the surface and then moving them around to see how they look in different positions. Consider the effects of placing a dark object on a light ground and vice versa, and combinations of natural and manufactured objects.

You can also create your own borders, which can be used around the edges as a frame or within a collage to separate one area or object from another. An effective border can be a simple row of seeds or berries on a contrasting background strip.

Overlaying objects

1 By using net or other semitransparent material in your collage, you can add texture without completely covering the background. Apply glue to the area you wish to cover and put the net in place.

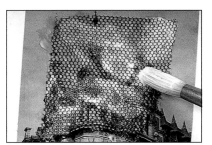

2 Press the net or other material down with a brush, making sure the whole area is glued. The glue can be diluted with a little water as the net will stick quite easily.

3 This can be overlaid with other natural or manufactured objects to build up interesting textures and compositions. A cog, for instance, provides a bold contrast to the delicate net and petal. Consider how much glue you will need to hold the object in position; a heavy cog will obviously need more than a dried flower head.

Altering objects

Depending on how you decide to use the objects in your collection, it is possible to alter them by various means such as painting, twisting and breaking.

Making paper semitransparent

1 Apply a generous amount of linseed oil to your selected image with a brush and allow it to soak in well. Black-and-white images can be enhanced by adding a small amount of oil paint. Remove any excess oil and paint by dabbing with paper towel.

2 Apply glue to the reverse side, place it over an area of your collage, and press down firmly, smoothing it with paper towel. When the glue has dried, parts of the background will become visible through the paper. Experiment with a variety of images and backgrounds for subtle and striking effects.

Using paint

It is also possible to transform dull objects by painting them using acrylic paint, which dries much more quickly than oil paint. Look at the objects in your collection and try brightening some of the duller ones with bold colors.

Altering objects with paint

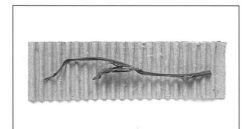

1 Certain objects, when placed together, can look rather dull. Their appearance can be enhanced by the addition of paint. This ordinary dried flower stem on corrugated cardboard can be made more dramatic by experimenting with different painted colors.

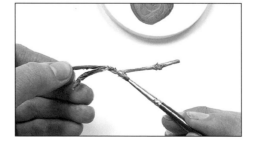

3 The flower stem is painted with a ready-mixed gold paint, using a small paint brush. Wear protective gloves if your hands are sensitive to metallic paints.

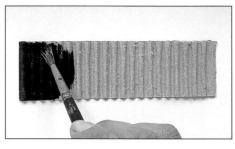

2 Mix a medium consistency of black or dark-blue paint and cover the corrugated cardboard with bold, downward brushstrokes.

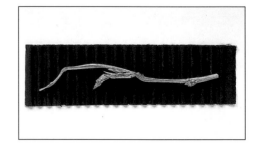

4 The combination of these two elements shows that objects can be altered quite dramatically. Consider which object in your collection could benefit by the addition of some color.

Breaking objects

Objects such as shells, seed heads, and model cars can be broken down and the resulting smaller elements used as individual objects or combined with others to add subtle textures to larger areas.

Adding texture

1 Choose an area of your collage which requires more texture and coat it with glue diluted with water.

2 Sprinkle the material you have chosen onto the glue. You may want to press the material into the glue with your finger or a piece of paper, depending on how dense you want the effect to be.

3 Allow the glue to dry and then brush away the material that has not stuck. By repeating this process, you can build up very thick areas of texture.

Using wire

Wire, which can be found in a wide variety of colors and thicknesses, can be twisted into many different shapes and trimmed to fit a particular space.

How to coil wire

1 Take the wire and an appropriate rod of thin metal or wood and hold each at one end. Coil the wire around the rod, making sure that the spacing of each twist is even.

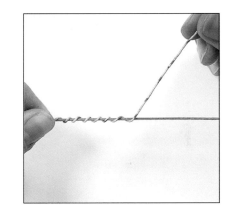

2 Ease the completed coil off the rod carefully so that it is not pulled out of shape. Trim the wire with pliers to the length you require.

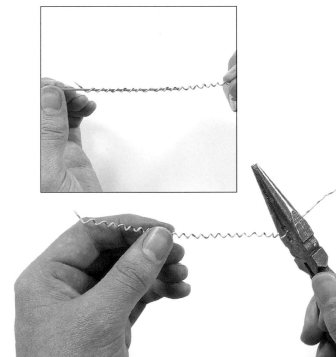

Once you have settled on a theme for a picture, you should assemble relevant source material and plan the picture – starting with the background.

Beachcombing picture

You can use a variety of source material to build up a background on which to begin applying your objects. Maps, in particular, provide an interesting surface, and can be torn or cut to any shape. Magazines contain images of every kind from which you can select areas for use as part or all of your collage base. Experiment with a variety of tones, images, colors, and using torn-and-cut edges, until you are happy with the look of your background and are ready to start assembling your collage.

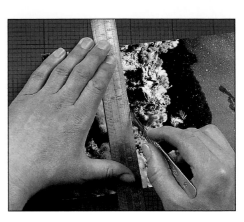

1 Using a craft (or mat) knife and metal ruler, cut strips from magazines, maps or wrapping paper in varying widths. Consider the size, color, and tone of the objects you are going to use.

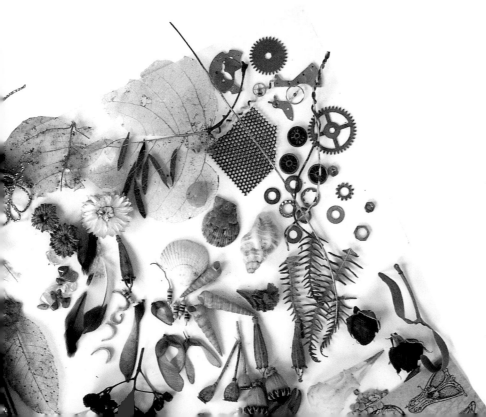

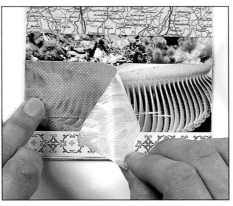

4 Start to build up layers of material by selecting an area to be made semitransparent, as shown in the techniques section. To attach the area which you have coated with linseed oil, cover the reverse side with glue and place over the background. Press firmly in place. The background should show through as the glue dries.

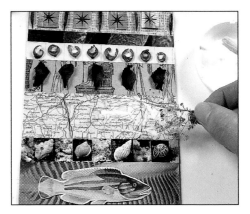

5 Continue building your collage by adding more material; rows of sycamore seeds, petals, shells, coils of wire, etc. Think about how these objects could be displayed in different areas depending on their size, color, shape, and tone.

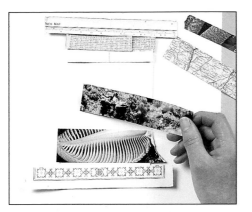

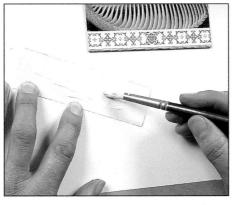

2 Place these in groups horizontally across a piece of cardboard and arrange them before gluing so that you have a mixture of colors, tones, and plain and detailed surfaces. Using scissors, carefully trim the overhanging edges of the paper strips.

3 When you have enough strips to cover the cardboard, glue the back of each strip and lay them in place one by one. Press each down firmly and remove excess glue with a cloth.

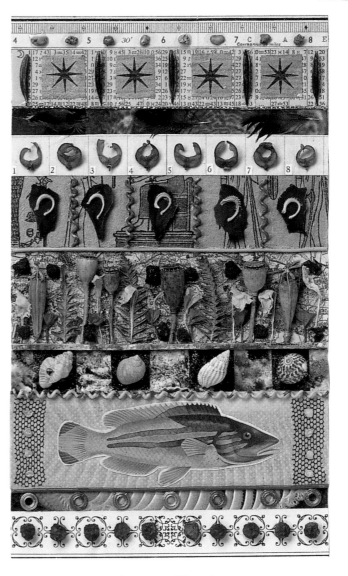

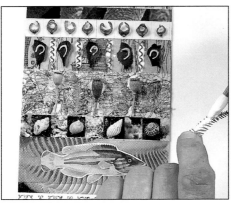

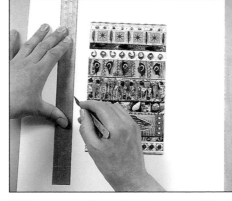

6 Some of the sections you have created may need to be made more distinct from each other. You can do this by introducing barriers of thread, wire, or thin strips of colored cardboard or wood to accentuate the divisions between areas. By choosing the colors carefully, you can also use these barriers to balance the final piece.

7 When your collage is finished, remove it from the board by cutting the stretched paper around the piece with a ruler and sharp knife.

Ocean and Beach

s t e p h e n b u t l e r

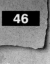
Found-object collage can be used to embellish many household ornaments – even clock faces!

Facing the clock

This clock would make a highly individual, yet useful, item for the home – or as a very special gift for a friend or relative. The intricate detail requires patience, but your attention to detail will pay off when the charming, finished piece comes together.

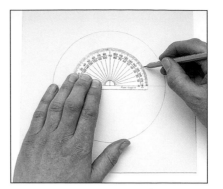

1 To make the dial, use a drawing compass to draw a circle with a radius of 3 inches (7.5 cm). Draw a diameter line across the circle through the center point. Place a protractor along this line and mark five points on the cardboard at 30° intervals.

2 Using these points, draw five more diameter lines, dividing the circle into 12 segments. This can also be done using a 30°/60° set square.

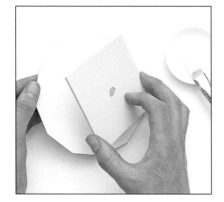

5 Cut two 4-inch (10 cm) squares of cardboard. Draw a ¼-inch (5 mm) radius circle at the center. Cut out a hole for the mechanism. These squares will be used to provide space between the dial and mechanism. Glue the two squares together, and then glue them to the back of the dial. Keep flat until dry.

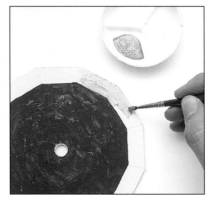

6 Paint the inner dial blue using acrylic paint. Paint the outer dial gold using acrylic paint. The cardboard may bend slightly at this point, but should flatten out again when the paint dries.

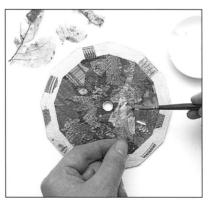

7 Build up the surface of the inner dial using paper cut and torn from magazines and painted photocopies. Painting the dial allows you to cover the surface quickly. Adding a layer of leaf skeletons will enhance the texture and subtlety of the surface without losing any of the color.

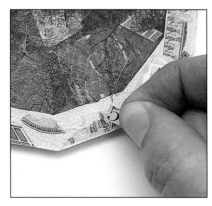

8 The flatness of the outer dial can be broken up by adding fragments of colored paper. At this point the numbers can be added. They can be cut from magazines or books.

This is the line you should ensure the hands can rotate without being obstructed by the objects on the dial.

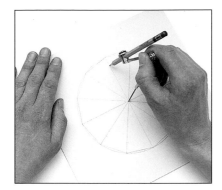

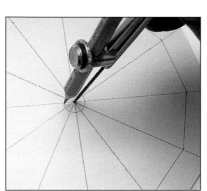

3 Using a drawing compass with a radius of 2¼ inches (6 cm), mark a point on each of the 12 radius lines. Join all the inner and outer points with a pencil, making a 12-sided shape with a ⅝-inch (1.5 cm) outer dial.

Cut this shape out carefully with a sharp knife along the outer lines.

4 Draw a circle with a radius of ¼ inch (5 mm) in the center of the dial. Cut around this circle carefully to make a hole for the clock mechanism. The size of the hole may vary, depending on the type of mechanism you are going to use.

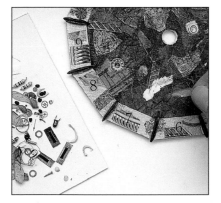

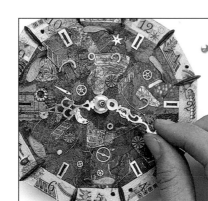

9 Start to add found objects to the inner and outer dial. Long, black seeds have been used here to divide the 12 sections on the outer dial. Applying gold-colored watch parts, brass washers, seeds, and other objects to the inner dial will provide a contrast with the blue surface and a link with the gold outer dial.

10 Assemble the dial with the quartz mechanism at the back and the spindle sticking through the front of the center hole. Attach your clock hands onto the spindle, then hold in place with the centerpiece.

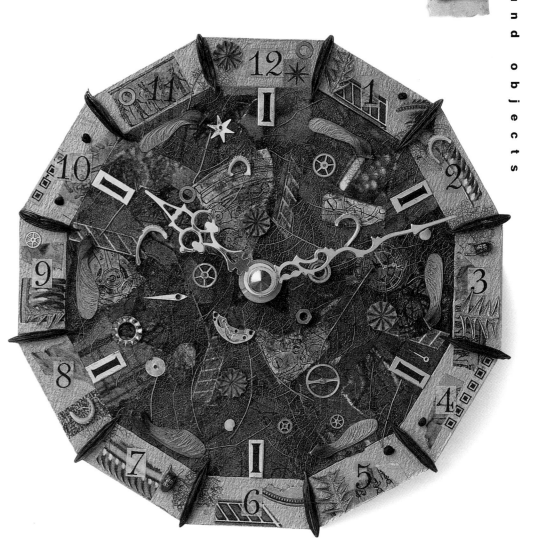

Finding the Time

stephen butler

This inspiring selection of work incorporates found objects from leaves, shells and petals to manufactured components and trinkets. The artists have made use of both frames and boxes in which to arrange their work; both offer scope for unusual compositions.

Gallery

The use of a deep box frame allows objects in relief to be incorporated into a found-objects composition. Here the structured lines of objects placed on luggage labels contrast with the random lines of the label ties and scattering of leaves.

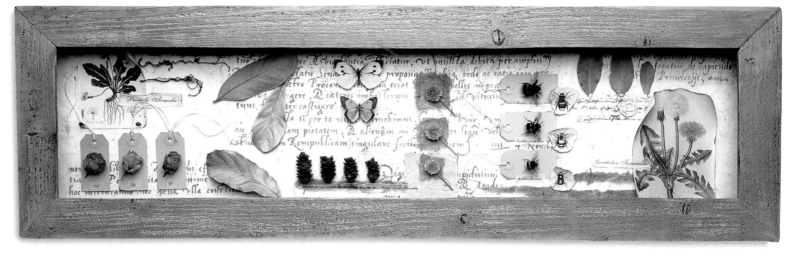

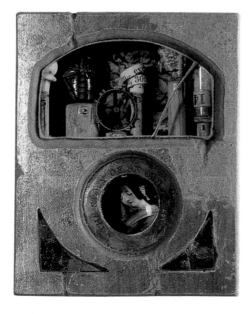

Keith E. Lo Bue

The Story of an Old Garden

Two windows in this brooch provide an ideal site for a collection of found-object fragments. The distressed appearance of the gold leaf on the face of the piece and the combination of wood, metal and glass objects gives this work a feeling of nostalgia.

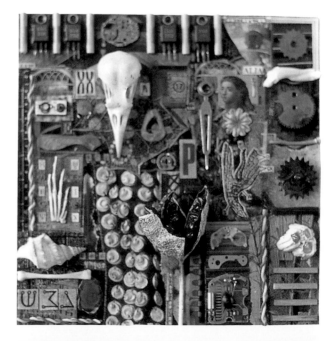

Nancy Gibson-Nash

Illustration for *Smithsonian Magazine*

Collage with found objects is ideal for illustrating particular themes or subjects. Alternative medical therapies formed the starting point for this work. The painted boxes provide a structured background in which to arrange herbs, bottles and medical paraphernalia.

Stephen Butler

Alia

LEFT: Fragments of watches, pictures, seeds and wires are just some of the components in this exquisite collage. The artist has been careful to balance the scale of the smaller items by the addition of the larger shell, skull, cog and seed pod.

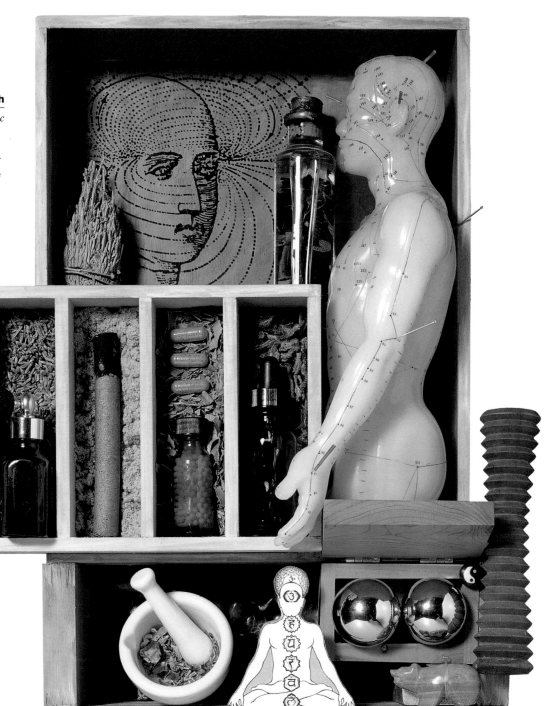

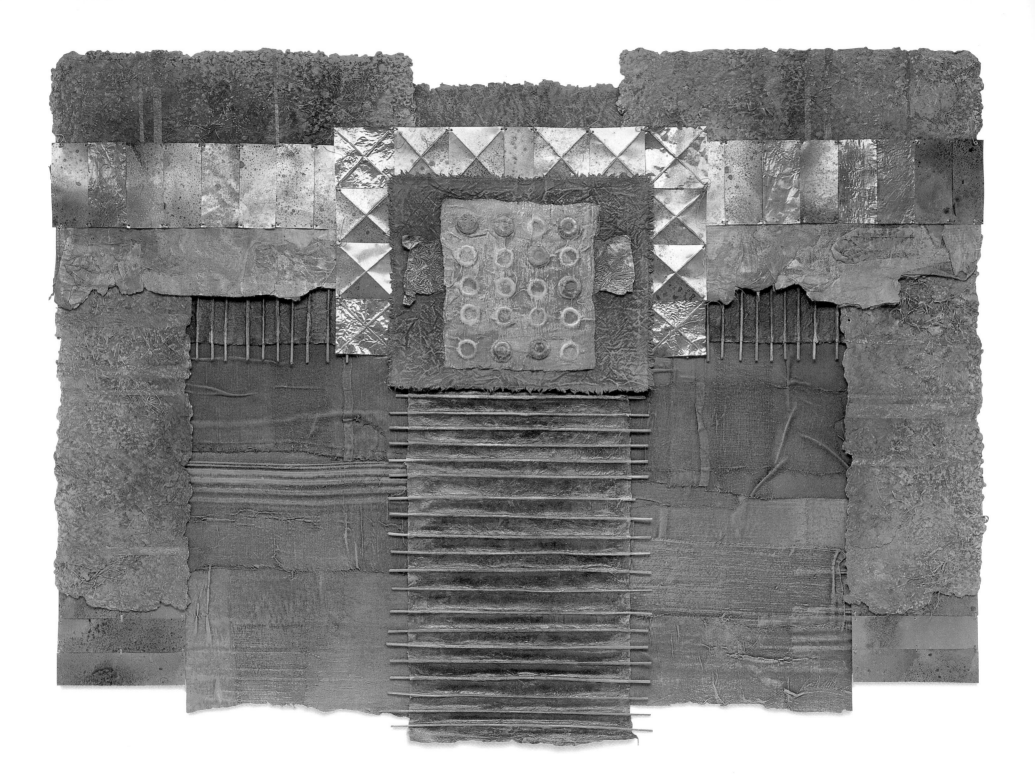

Mixed-media collage is a versatile medium. With so many different techniques to explore and so many combinations of different materials to mix together, the possibilities are endless.

Mixed-media

The collage artist is always on the lookout for interesting objects that could be incorporated into his or her work. Start looking around for things you could use; materials don't have to be expensive. The beauty of mixed media work lies in the fact that work can be made using all sorts of things – old packaging (labels, flattened tin cans, corrugated cardboard), newspapers, threads, fabrics, leaves, painted papers and pictures from magazines. Choose just two or three contrasting types of materials and objects at first, and experiment to try to get them to work in harmony together.

Once you feel things work well together, you can try to incorporate more into one image. If you use too many different materials and objects, your work could look cluttered and confused.

The following section gives you information to help you to create your own mixed-media collages. There are clear, practical suggestions on the selection of materials available, as well as a variety of creative techniques to explore as you experiment with mixed-media collage.

Mixing the textures in your collage can help make your work more interesting. Consider the variety of different contrasting surfaces and alternative combinations that are possible. Combine thick rough materials with open-weave transparent fabrics and soft shiny silks and satins. Foil wrappers, corrugated cardboard, and colored acetate can all provide contrasting textures.

Materials and properties

Mixed-media collage uses many layers to create the finished effect. This means you can always eliminate unwanted parts of a collage by gluing new material over it, or painting over the undesirable section.

Don't worry too much when you start about exactly how you want the finished collage to look. As long as you have a basic idea, you'll find that once you begin you'll think of other things to add (or take away) later.

fabrics

Whether you buy new fabrics or use materials ripped from old clothes, the different thicknesses, textures, and colors offer a wide choice. Calico, silks and satins, muslin, felt, and upholstery fabrics all work well.

Very different effects can be achieved with cut, ripped, or frayed edges to your materials.

using fabrics

As a rule, thicker, tougher fabrics work well as a base to your collage, and thinner fabrics (those that are easier to manipulate and distress) are more successful to provide surface textures, although rules are made to be broken.

papers

There is a huge selection of handmade and manufactured papers on the market today, from colored tissue papers, crepe paper, and wallpaper to handmade papers (leaf and petal papers, Japanese papers) and old newspapers (especially those written in another language).

packaging

The range of papers and various materials used in packaging is so enormous that some collage artists use nothing else to create their collages.

Collect corrugated cardboard, bubble wrap, brown paper, printed labels, flattened tincans, aluminum foil, and candy wrappers, in fact any clean packing material can be used.

paints and inks

There is a vast choice of paints and colored inks available from art and craft shops and stationery stores.

Acrylic, gouache, poster paints, watercolors, colored inks, oil pastels, and chalk pastels all have their uses. Oil paints are not recomended for general use as they take a long time to dry.

effects of three-dimensions

You can create much more depth within your collage when interesting shadows are cast across your work, and contrasting textures become more evident when a third dimension is added on top of them using found objects, like shells or pine cones, or those you make yourself from oven-bake or modeling clay.

found objects

One man's trash can be your treasure trove! Found objects, whether natural or manufactured, can be collected from anywhere – from the countryside or behind the supermarket – and are invaluable to the mixed-media collage artist.

think ahead with 3-D

Before you glue three-dimensional objects on a collage, you have to consider the weight of the objects and whether the piece will be able to support them.

color versus black-and-white

Black-and-white photocopies are "neutral" in color, so they can be used successfully with any painted color, whereas colored images are more difficult to coordinate.

However, when color images are used well with their painted background, they can look stunning. Use a background color that's predominant in the color image, or try a contrasting color to make the predominant color in the image stand out.

printed images

Printed images can be used by themselves in a collage or montaged together to take on a new meaning. Photographs, whether color or black-and-white, give a bolder, more contemporary – and often a more documentational feel – to your work, whereas using sections of old paintings can give a subtler, more traditional effect in your collages.

Adding color to a collage, with paints or inks, can really affect the "mood" of the piece. Using delicate blues and greens can give a tranquil, peaceful feel, while fiery oranges and vibrant reds can evoke passion and anger. Mixing bright colors together can make a collage look childlike and fun.

Combining images, color and texture

Harsh and soft textures can affect the overall feel of a collage, so think carefully about what mood you want to evoke and the various methods you could use to achieve the right results. A wide variety of materials can be used, from tissue paper to handmade paper to give a more textured feel.

Combining images

In order to blend the different aspects of your collage together as a united whole, give some thought to whether your different two-dimensional images should have sharp, cut edges or ripped edges, or both, to create contrast within your collage.

An alternative way of bringing together different images is to blend a chosen image into the background by pasting tissue paper, handmade paper, or thin fabrics over the edge of the image so that only part of the image – the area you feel to be the most important – is visible in the collage. This means that you can decide whether to leave it visible, or crop it tightly against a foreground image.

You can even show just half an image to give a suggestion of the whole. When this technique is used with dark, moody colors, it adds a mysterious feel to your work.

1 Rip off the excess paper from around your chosen image. Here the photograph has been tightly cropped. Decide how much of the image you want to remove before you start to rip – you could always cover over any excess background which you don't like, later.

2 Glue the reverse of the image and stick onto the background collage. Now glue small pieces of the covering material around the part of the image you want to be visible.

Working with painted color

Other chapters in this book have already covered many techniques involving color, many of which can be used in mixed-media collage. I am going to concentrate on the effects that can be achieved by combining color with texture.

You can create more depth to the color in a collage by applying many layers of paint and waiting for each layer to dry before adding the next.

Rather than just painting an even coat of color over the various layers, try using paint to highlight the textures to their best advantage. Use darker colors for the lower points and highlight, perhaps in gold or silver paints, the top ridges of the folds. Applying darker colors under three-dimensional objects like shadows can also look very effective, giving the collage an even more three-dimensional effect.

Sand, salt, or tiny glass beads can be added to paint to thicken it and give a rougher texture.

Watered-down paint or ink can be used sparingly over black-and-white images to great effect, either adding color to highlight a section or "washing" over a whole image to create contrast with the background coloring.

Three-dimensional effects

There are many three-dimensional effects that can be achieved in mixed-media collage.

String, wire, or pipe cleaners can be used to make shapes and patterns or to reinforce the outline of a photographic image. They can also be glued around the edge of a piece to create interesting borders.

Using found objects on a collage can really take your work into another dimension! Whether you look for things in the park or the forest, or in toy stores or garden centers, or even use objects lying around your home, there is such a vast number of combinations to try out that the possibilities are endless.

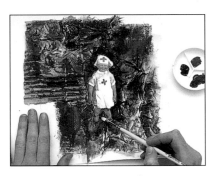

1 Paint the base color evenly over the collage using a large brush.

Use a smaller brush to add slightly darker shade around the edges of the central image, towards the base of any folds and behind the frayed ends – this creates a feeling of depth. Add lighter tones to the tops of the folds or in flatter areas of the collage.

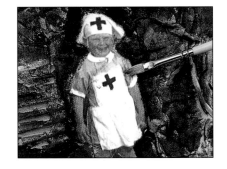

2 Adding a wash over parts of the central image helps to focus attention on the more important sections of the collage. Here the artist has used a pink wash for the nurses uniform and has highlighted the red cross on the apron.

Three-dimensional effects: Gluing objects to your collage

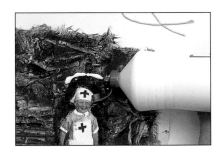

1 Run a thin trailing line of glue along the line you would like the string to follow. Put glue on the string itself and carefully position it along the trail on the collage.

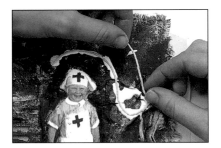

2 Hold the string in place for about 10 minutes. Keep an eye on it after that so if it slips off the glue, you can put it back in place before it all dries. Using a hairdryer can quicken the process if you're impatient!

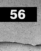

Transferring images

You can achieve some really interesting and intriguing effects with a technique called image transfers, whereby a photocopied image (from a black-and-white photocopier or a color laser copier) can be transferred onto another surface, such as wood, metal, fabric, or textured paper. This technique uses cellulose thinner which can be bought from do-it-yourself stores and paint distributors.

Cellulose thinners, when rubbed on the back of a photocopy, break down the printed image and transfer it, reversed, onto another surface of your choice. The final image is a subtle version of the original and when used in collages can give your work a softer, more fragile feel. This technique doesn't work on photographs, or printed images taken from a magazine or book. Always work in a well-ventilated room as the fumes can be overpowering at times.

Image transfers using cellulose thinner

1 Take a black-and-white photocopy or color copy of your image. Have a few examples of the same image on hand, as you are unlikely to get the exact effect you want on the first try. Rip off the unwanted part of the image. Using masking tape, secure the photocopy along the very edges face down on the surface you wish it to appear on – watercolor paper, wood, metal, or fabric, for example.

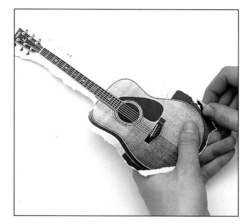

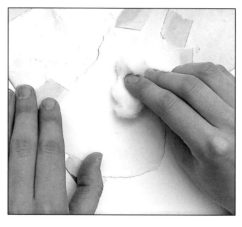

2 Pour a very small amount of cellulose thinner onto some absorbent cotton (cotton wool). When the cotton is nearly dry to the touch, repeatedly rub it all over the photocopy.

If there is too much cellulose thinner on the back of the image the paper will become transparent, and the technique may not work.

3 Now, using the handle of a craft knife or a similar blunt instrument, rub firmly but carefully over the back of the entire image, as if you were rubbing the back of a transfer. You need patience and you may need to rub the photocopy with cotton one more time to release stubborn parts of the image.

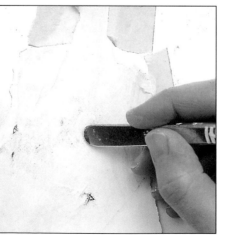

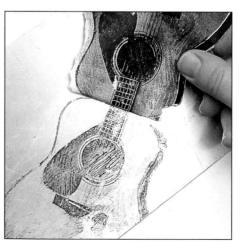

4 Now remove the photocopy carefully, and you will see your chosen image reversed on the surface of your choice.

Working with modeling clay

Modeling clay can be bought from most art and craft and hobby stores. You don't have to be an expert to achieve good results, because when you're combining modeling clay with collage, the emphasis is on creating varying textures that work well together, not on the technique.

Whether you just make three-dimensional shapes and patterns on your collage or attempt something more adventurous, it is an inexpensive medium to experiment with and can be a straightforward method of creating more depth to your work.

Modeling clay can also be combined with copper wire or string to create a loosely jointed object. Even if the first objects you create look a little rough around the edges when they're dry, this quality can add to their charm in a textural collage.

Working with modeling clay

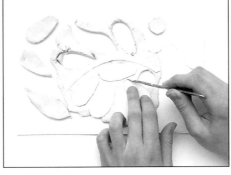

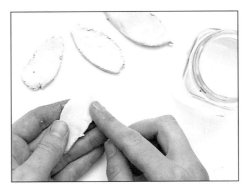

1 Draw the object you wish to make. Remember it must be relatively flat on one side. If it incorporates different sections draw these sections separately. The drawing will be used like a sewing pattern. Cut out each section to use as a pattern for the final model.

2 Roll out the clay and place each piece of the pattern on it. Cut around each part of the pattern with a scalpel or modeling tool. Put the unused clay away before it dries.

3 Smooth the rough edges of the clay shapes by dipping your fingers in water and gently running them along the coarse edges.

4 Using a needle or the point of a pencil, punch holes in the clay shapes in the places where you want the pieces to connect. When the pieces are dry, you can connect them by threading string or copper wire or any type of thread through the connecting holes.

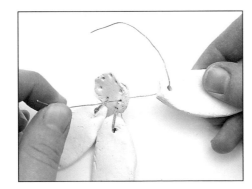

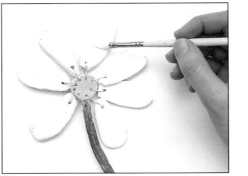

5 You can either leave the clay its natural color or paint it. You can leave the surface matte in texture or varnish your clay object to create contrast with the background collage.

Your objects can now be glued, using a suitable adhesive, to your collage.

This is an ideal present to give someone for a birthday, Christmas, anniversary, or wedding gift, since it can be personalized in any way you choose.

Three-dimensional picture

You could use an old photograph of the recipient as a child, or a newer one with his or her family, or a group of friends together. You could also blend other information into the background collage – maybe some text about their horoscope sign, or an image showing a place that is important to them (whether it's a building, a monument from a particular place, or a section of a map). The more thought you put into the preparation, the more individual and unique this collage can become.

1 Cut, rip and fray the various materials you wish to use for the background. These can all then be glued to the backing paper using white craft glue (PVA).

2 Cut or rip unwanted edges from the photocopies you have chosen to use. If you have different images you wish to incorporate together, try them in different positions before gluing them into a final arrangement.

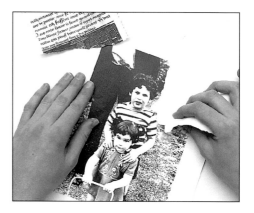

3 Blend the photocopies into the background collage using tissue paper, handmade paper, and/or transparent fabrics. You can also add extra sheer material at this stage to create more textural depth.

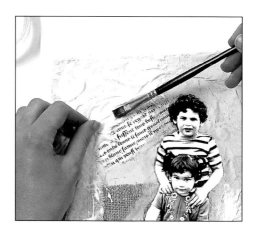

4 When the collage is dry paint on a base color using a large brush, then let it dry before applying darker shades around the focal image and in selected areas using a slightly smaller brush. Once dry, add highlights using gold or silver paint.

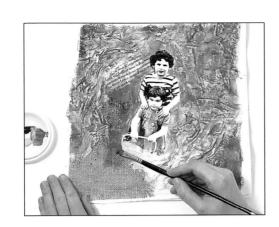

5 When the collage has dried, decide where you would like your three-dimensional objects to go before gluing them onto your collage using a strong adhesive.

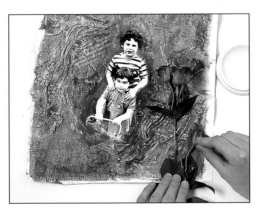

6 Rip off the visible edges of the backing paper before mounting the collage onto a backing board. Either glue or stick it down with double-sided tape. Trim the piece down to size and place it in a frame.

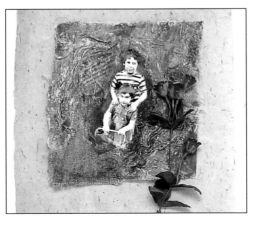

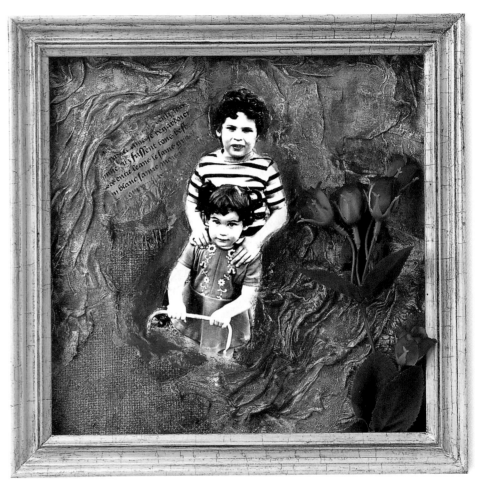

Two Children and Roses

n i n a d a v i s

This project is a great way of transforming your mixed-media techniques into a personalized practical object that is also an ideal gift.

Decorated plant pot

It is a good idea to decide on a theme in which to decorate your pot. Here the artist has used the garden as a starting point, however you could use the beach or a subject such as your street as a theme. Alternatively the color scheme of the room for which your pot is intended could provide design ideas.

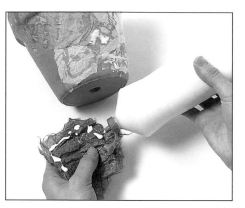

1 Rip tissue paper, and other materials, into small pieces to cover the exterior of the flowerpot. Either use tones that will be visible in the overall base color or stick to neutral colors that can be painted over. Glue them down with craft glue. It doesn't matter if the tissue paper or fabrics are creased as this will add to the overall texture.

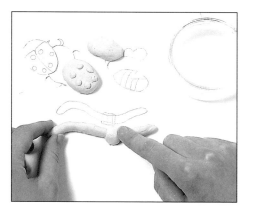

4 Using the modeling techniques outlined on page 57, make the bees, ladybugs and worm. If you don't wish to make your own, use bought objects.

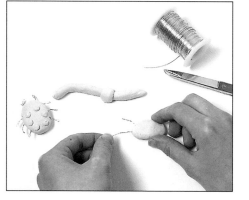

5 Cut small lengths of copper wire for the antennae and legs of the garden creatures. While the clay is still soft insert the wire firmly.

6 When the clay has dried, paint the objects using acrylic paints. Paint basic colors first, then add finer details using a smaller brush if you wish.

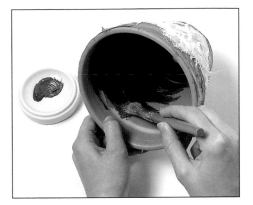

2 After the exterior is dry, paint the interior and the base of the flowerpot with a plain color.

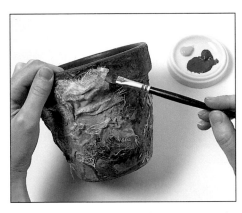

3 Add painted color to your tissue paper and materials using darker tones in selected areas and highlights on the upper ridges. Let it dry.

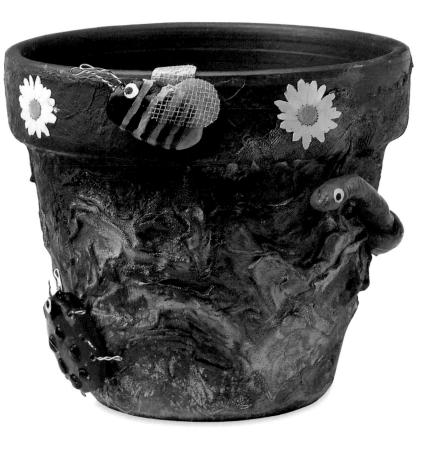

Bugs and Bees plant pot

n i n a d a v i s

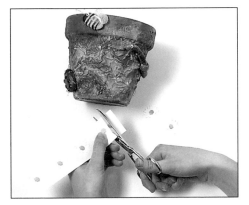

7 When your objects are dry, glue them to the pot using a strong adhesive. If you feel more decoration is needed, add some two-dimensional color images. I cut out color photocopies of a daisy and glued them around the rim.

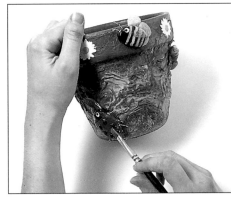

8 When the glue and objects are completely dry, coat the plant pot with several layers of varnish to protect it. If the pot is purely for decoration, you could decide to varnish only some elements of the pot (for example, the three-dimensional creatures) to create a contrast between the different textures.

Incorporating several collage techniques, mixed-media work allows the artist to experiment widely with different mediums to create work of remarkable originality. These pieces combine distressed surfaces, paint effects, found objects, and fabrics to create unique collages.

Gallery

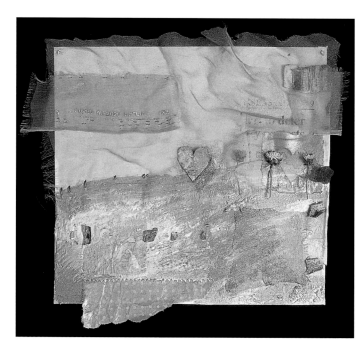

Sarah Lugg

Indian Summer

Textured washes of color form a base for applied layers of gesso and paint. The artist has also loosely couched the fabric in this piece, which was inspired by the delicate beauty of Indian silks.

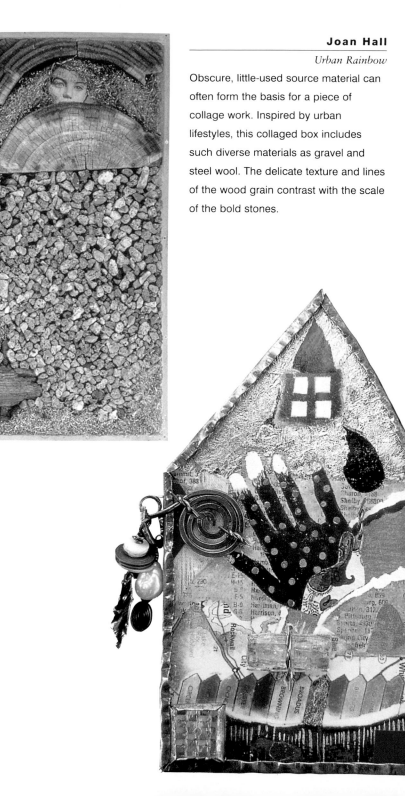

Joan Hall

Urban Rainbow

Obscure, little-used source material can often form the basis for a piece of collage work. Inspired by urban lifestyles, this collaged box includes such diverse materials as gravel and steel wool. The delicate texture and lines of the wood grain contrast with the scale of the bold stones.

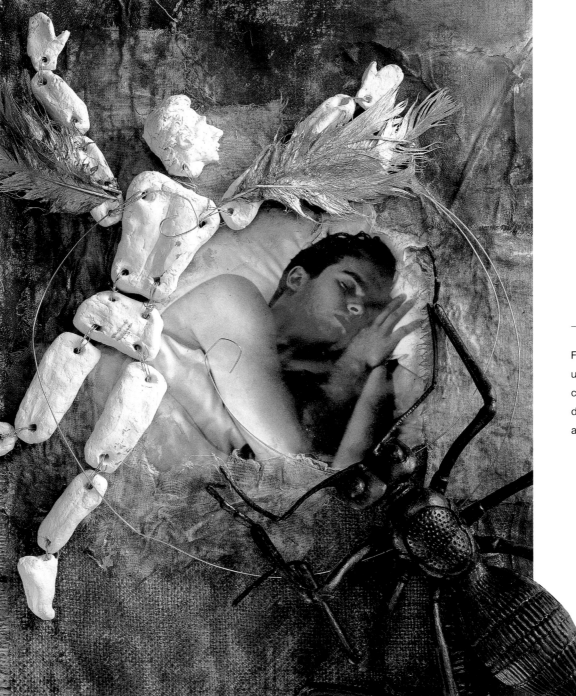

Ken Bova

On My Way Home

LEFT: Fragments of papers, maps and mileage charts have been scored, folded and ripped and then combined with metals and gold paint to create this lively work inspired by the artist's travels around Montana.

Nina Davis

Clay Figure

Frayed cheesecloth (muslin) has been used effectively in this mixed-media collage to merge the seam along two distinct areas between the photograph and the heavier painted canvas fabric.

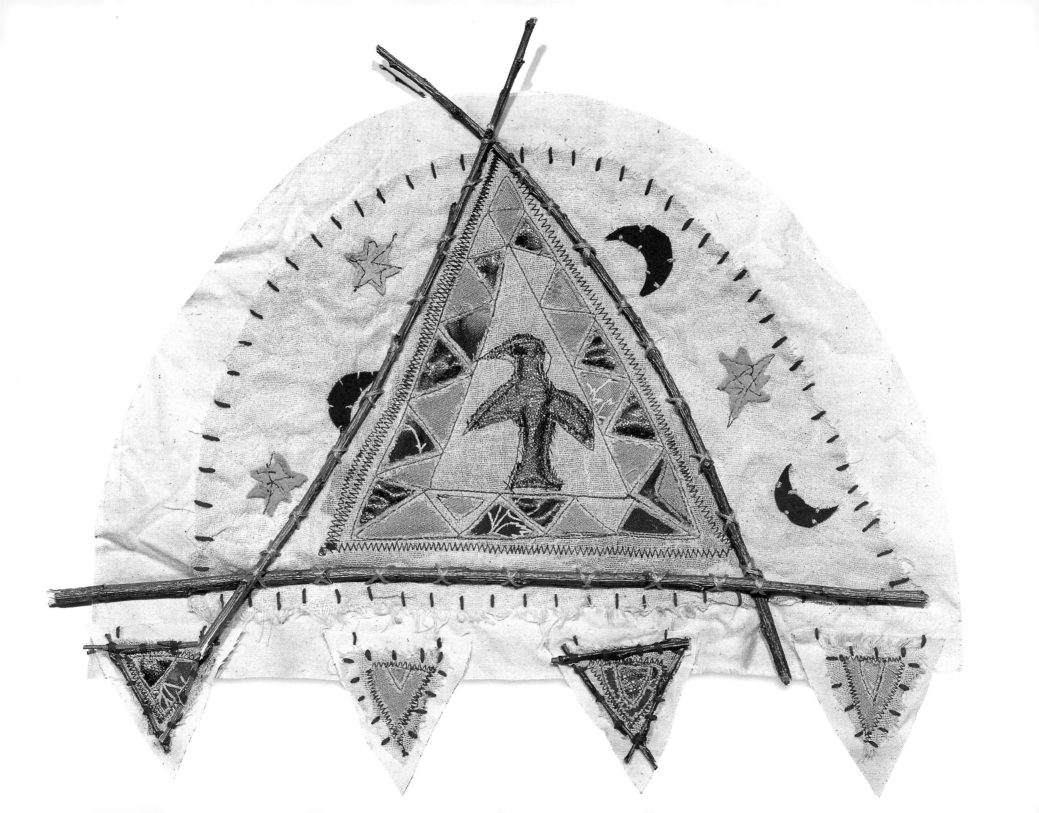

The art of fabric collage is traditionally known as appliqué, and using fabrics as a medium opens up a whole world of possibilities. There's no right or wrong way to do it; you can be experimental and make it as complex or simple as you wish.

Fabric Collage

Any type of fabric can be used, and with the wide choices now available you can be sure to find interesting and inspirational materials for your collage. The fabrics needn't even be new or bought specially – scraps of fabrics found around the house work just as well.

Designs can come from images you see or be inspired from the fabrics you use. They can be lavishly embellished with stitches, beads, and buttons or left plain and unstitched, using just the fabrics and shapes to give them form and texture.

Fabric collage lends itself well to abstract, naive, and childlike designs, but can work extremely well in a whole range of other styles. Cutting out shapes means the composition can be arranged and rearranged before you decide on the final design. Fabric collage can also include other materials such as paper or cardboard, and designs can follow a simple color scheme, or mix several colors, patterns, and textures.

The collage can be any size and used for anything from pictures and hangings to cushions and quilts, and can also be added to embellish and liven up existing fabrics and clothes.

There is such a huge selection of fabrics readily available nowadays that it is often confusing to decide which ones to use! If you have a design in mind, you can use fabrics and colors that are suitable to your needs. Occasionally very effective collages can be achieved by selecting fabrics that inspire you first and working a design around them.

Materials and properties

Usually the first place to start when choosing material is by deciding on the fabric you wish to use as a background. Large areas of fabric background often look best in a plain-colored fabric as opposed to a busy, multicolored one. As a contrast to a plain background, small pieces in a patterned fabric can look very effective as long as you take time and care in selecting the correct color scheme and use the fabrics to their best advantage.

transparent fabrics

These give a lovely delicate effect to collage and work extremely well when layered. Lace can be used to give an extravagant effect; if you want a plainer look, use net or gauze.

printed fabrics

Printed fabrics, such as florals, are very common and come in a vast choice of colors. The patterns vary in size from very small delicate prints (ideal for small areas of collage) to larger, bolder prints.

cut and frayed edges

Fabric edges needn't always be hemmed – some fabrics can be cut with sharp scissors to give a clean edge or with pinking shears to give a zigzag effect. Frayed edges also look effective, provided the fabric lends itself to being frayed. Interesting effects can also be achieved by ripping the fabric.

manufactured fabrics

These are slightly more difficult to work with than natural fabrics since some have a stretchy, elastic quality, such as Lycra or nylon, but they often come in a variety of bright colors.

natural-fiber fabrics

These are very popular, as neutral colors can easily be dyed to the color of your choice. Textures can vary from soft and smooth, such as silk and fine cotton, to the rougher, uneven weaves of raw silk and burlap (hessian). Plain-colored fabrics are ideal for backgrounds.

finishes and textures

Different effects are created by the finish and texture of the fabrics used. Some interesting textures include silk, burlap (hessian), terry cloth, net, suede, gauze, corduroy, leather, satin, and denim.

recycled fabrics

Recycled fabrics found around the home can be used in collage. Old clothes are ideal, and scraps of fabric from discarded sheets, curtains, and towels also work well.

open weaves and transparent fabrics

Fabrics which have a loose, open weave and transparent fabrics work especially well layered and applied over other fabrics to give greater texture.

woven patterns

These are found mainly in upholstery fabrics and provide excellent texture, lending themselves particularly well to large areas of collage.

mixing patterns

Try using several different patterned fabrics together, combining varying scales of print. You can stick to a common color scheme or experiment with clashing prints and colors.

With the wide choice of fabrics available nowadays, it's easy to find almost any color and pattern you need. But dyeing and decorating your own fabric can be fun and gives a unique result.

Painting and dyeing fabric

Some fabrics will not hold dyes, but some fabrics, such as cottons, silks, and linens, are ideal. There's no end to the different effects you can produce, and the techniques range from the most simple and basic to more complicated and skilled.

Adding color and pattern to fabrics

The fabrics being dyed or patterned do not need to start off solid (plain) white. Exciting results often come from dyeing materials that are already patterned, such as ginghams or small florals, or worked on top of a fabric that already has been dyed.

The advantage of dyeing and decorating fabrics yourself is that it allows you to get the exact colors and patterns you want, harmonizing and matching styles, and it also produces unique fabrics.

Whatever technique you try, use your imagination. Don't be afraid to experiment until you get the result you really want.

Painting silk

1 Stretch the silk taut over a frame using thumbtacks (drawing pins).

2 Draw the pattern on the silk using special silk-painting gutta.

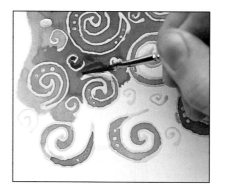 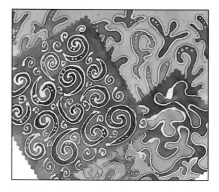

3 Once the gutta has dried, paint the background using silk paints. The gutta will prevent the colors from spreading.

4 Wait until the paints have completely dried before unpinning the silk from the frame. The finished painted silk can be used in your fabric collage to give an interesting pattern and texture.

Dyeing

Dyeing fabrics at home has never been easier. Fabric dyes are readily available in a wide choice of colors, and they are generally very simple to use. Colors can be mixed together to vary the tone, and experimentation is very much the key here.

Tie-dyeing is a very easy technique, and produces wonderful results. Silk and light cottons are the easiest to tie-dye, and often work best. There are many methods of tie-dyeing; once you become more confident in the basic techniques, you can experiment and make up your own methods. (Before tie-dyeing please see the tip box on page 70.)

Tie-dyeing using beads

1 Tie the beads tightly at random in the fabric using strong thread.

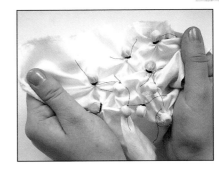

2 When all the beads are tied in, the fabric is ready to be placed in the dye. For best results, wash the tied fabric with water before placing in the dye.

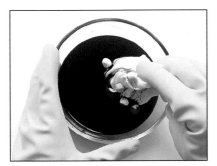

3 Wearing rubber gloves, make up the dye according to the instructions on the package. Large amounts of dye are best prepared in a bucket with all the surrounding surfaces well covered! Place the fabric in the dye and gently stir it, ensuring that all the fabric is submerged.

6 Take the fabric out of the plastic bag and rinse thoroughly in cold water until the water runs clear. Unpick the threads and remove the beads. Rinse the fabric again in hot water.

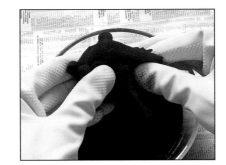

4 Leave the fabric in the dye for the length of time stated in the instructions. If no time limit is suggested, half an hour to an hour should be sufficient. To take the fabric out of the dye, wear rubber gloves and make sure the surrounding area is covered.

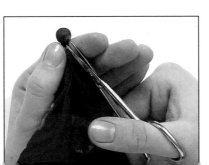

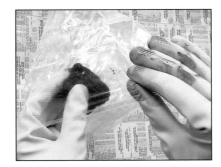

5 After the fabric has been taken out of the dye, place it immediately in a plastic bag, seal it, and leave it for 3–4 hours or overnight.

Leave the fabric to dry away from direct heat and then press with a warm iron. Changing the size of the beads or using other items, such as rice, pebbles, and so on, will vary the size of the circles made.

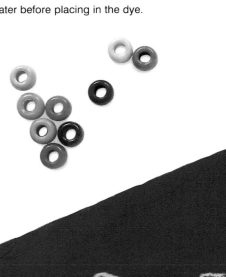

Tie-dyeing techniques: Stripes

1 Lay the fabric on a flat surface, and carefully fold back and forth in pleats. When all the fabric has been folded into a thin strip, tie tightly at regular intervals with strong thread. Dye in the same way as the bead-dyeing technique.

2 The finished fabric will be dyed in stripes that can be varied by tying the thread closer together or farther apart.

TIP

When using purchased dyes, it is important to read the instructions very carefully. Always cover the surrounding surfaces and your own clothes to avoid dyeing more than you want! Also, dyes can stain and irritate skin, so it is important to wear rubber gloves.

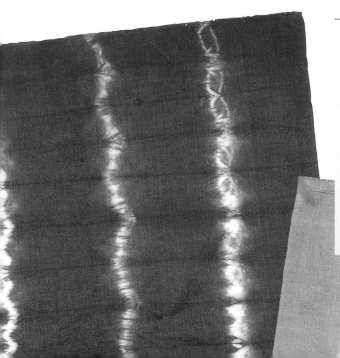

Tie-dyeing techniques: Circles

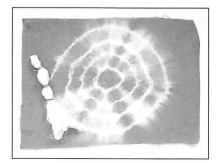

1 Gather the center of the fabric into a cone shape and tie at intervals with strong thread. Dye in the same way as the bead-dyeing technique shown on the previous page.

2 The finished fabric will show tie-dyed circles. Different effects result if the threads are tied closer together or farther apart.

Tie-dyeing techniques: Marbling

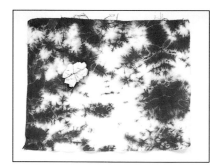

1 Scrunch the fabric up tightly and bind it with strong thread. Dye in the same way as the bead-dyeing technique on the previous page.

2 Every piece of fabric will be dyed differently. By tying the thread loosely, the dye will cover the fabric more densely.

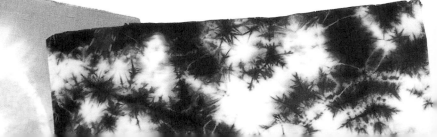

Patterning: The art of batik

Batik is an extremely useful technique, but as a proper wax pot is needed, it can prove costly. The pot melts the wax so that it can be used to "draw" patterns on the fabric, using a tool called a *tjanting* (see Step 1 picture, *below*). The molten wax is held in the tjanting's bowl and it flows through a smaller hole in the nib.

The wax cools on the fabric, it prevents the dyes from coloring the fabric beneath it and spreading into other areas, allowing the rest of the fabric to be dyed. The wax is removed by ironing between sheets of newspaper.

Patterning: Drawing with dyes

Another method of patterning fabric, and one that isn't expensive, is drawing directly onto the fabric using fabric or silk paints and pens, as shown on page 68. When you use silk paints, you should use a substance called gutta to draw the pattern first. Gutta usually comes in an easy-to-use tube, and works in a similar way to batik wax by stopping dyes spreading into each other.

The dyes can be special silk paints, ordinary fabric paints, or dyes. Food coloring also works well, but it is not colorfast, so the item can't be washed.

Batik technique

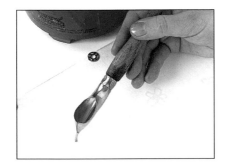

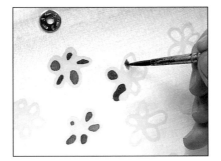

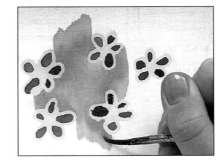

1 Once you have pinned your fabric onto a frame, use the tjanting to scoop up melted wax carefully from the pot. It may be useful to have a paper towel or a piece of newspaper handy to wipe the nib and prevent drips as you carry it over the fabric. While the wax is still very hot, draw the pattern on the fabric with the tjanting.

2 Once the wax has dried, the fabric can be painted. Dab the brush lightly on the fabric, allowing the dye to spread to the edges of the wax.

3 The background can be painted in the same way using a thicker brush. Uneven color tones can give the fabric an interesting texture.

4 When the dye has dried, unpin the fabric from the frame and place it between several sheets of newspaper. Gently press a hot iron over the newspaper to melt the wax from the fabric.

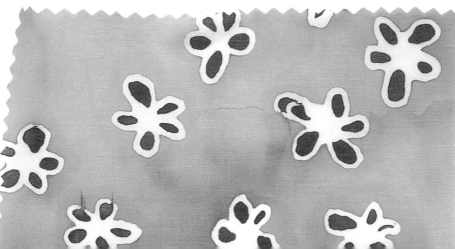

When all the wax has melted and been absorbed into the newspaper, the fabric will feel soft again and be ready to use.

The art of appliqué, or fabric collage, is a traditional needlework technique, yet it doesn't necessarily require any stitching at all. There are many methods of securing fabrics to a background.

Fixing fabrics together

Fixing fabric to a background

How you decide to attach your fabrics to their bases depends on a number of factors. First, consider how sturdy the piece you are making needs to be. For instance, if you're making something that will actually be used, such as a collaged bag or apron, the pieces will need to be fastened very securely to the base fabric to prevent them from coming away and possibly falling off. But if you're making something just to be looked at, such as a picture or hanging, the pieces needn't be secured as firmly, although you may choose to as part of the overall design.

You must also consider the nature of the fabrics themselves. You may wish to turn under the edges of a shape, but if the fabric is particularly thick, this may not always be practical. Turning under the edges of a very small or strangely shaped piece may be tricky, and you may have to find another technique.

Above all, try different techniques first to see which ones work best for you and your design.

TIP

When using bonding web, always make sure the iron never comes in direct contact with the glue web, as it will melt onto the base of the iron and stick to it.

Paper-backed bonding web

This is the simplest method of fastening fabric shapes to a background. Fusible bonding web is essentially a web of glue which melts when ironed to literally bond two pieces of fabric together. It allows you to draw the shape you wish to cut out on the paper backing first, and it also means you can cut out and collage very small pieces easily.

Using bonding web

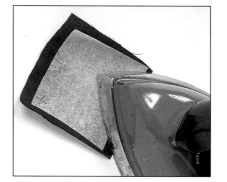

1 Cut a piece of paper-backed fusible bonding web and make a pencil cross on the paper side to avoid ironing the wrong side. Place the bonding web on the wrong side of the fabric, paper side up and press with a hot iron until the two pieces are fused together.

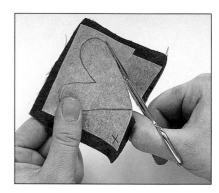

2 With a pencil, draw the required shape on the paper backing and cut out.

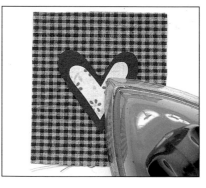

3 Peel the paper backing from the fabric. The bonding glue should be stuck to the fabric. Position the shapes on the background fabric, taking great care that the webbed side of the fabric is facing down. Gently press with a hot iron until the fabrics have fused together, or you can stitch them by hand or machine for extra security.

Hand stitching

Stitching the pieces by hand is a good way to secure them firmly to their base. You can use many different hand stitches and vary the thickness of the thread to enhance the overall design. It is often easier, especially where small pieces are concerned, to hold them in place using bonding web before you start to stitch them down. Very small stitches can be used as a discreet way of securing the pieces, or larger stitches using embroidery thread, for example, can become an important feature of the design. Try mixing the colors of thread and fabric, or experiment with collaging fabrics of just one color and contrasting them with the color of the stitches.

Machine stitching

Machine stitching is an ideal technique to use in fabric collage, although it can be a bit tricky, especially if the pieces are small, so you may need to practice first.

As with hand stitching, smaller pieces should be secured to the base first with bonding web. Larger pieces can be kept in place with basting (tacking) which can be removed. You will need an embroidery or darning foot on the sewing machine. Drop the feed dog to allow you to move the fabric in all directions. Both running and zigzag stitch work well in fabric collage.

Hand stitching

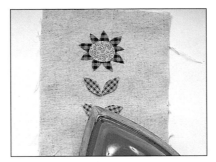

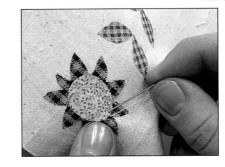

1 Iron bonding web onto the back of your fabric. Draw shapes onto the paper backing. Cut them out and peel off the paper before placing the shapes. Gently press with a hot iron.

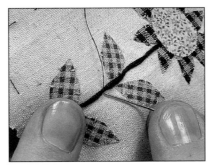

2 Use sewing thread to secure the shapes on the background with small stitches that catch the edge of the pieces.

3 When sewing things like flowers, stems often work best if they are made from thicker braids, ribbons, and cords couched onto the background (see below).

Using large stitching

Use thicker threads, and try a variety of different stitches.

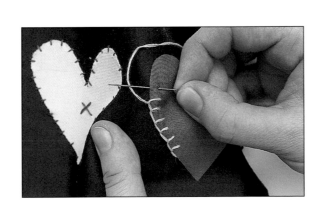

Couching technique

Couching is the term used when embroidering a design by laying down a thread and fastening it with small stitches at regular intervals.

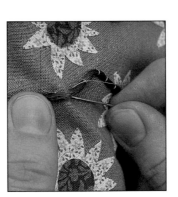

The couching technique is ideal for sewing stalks onto flowers.

This wall hanging would make an ideal gift for a family member or friend.

Hanging heart

This design would look great for a bedroom or in a nursery. If you are intending to use the hanging in a child's room place it out of reach and make sure buttons, and so on, are secure.

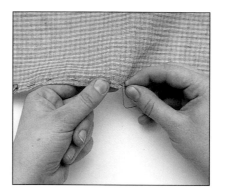

1 Cut the background fabric to 12½ x 15 inches (32 x 38 cm), then pin and baste (tack) the edges. Cut two squares of a contrasting fabric to use as patches and pin and baste the edges.

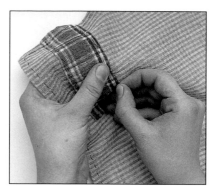

2 Sew the patches to the background fabric using small stitches. The basting stitches can then be removed.

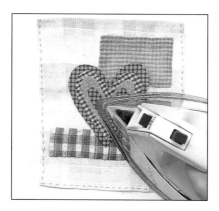

5 Peel off the paper backing, arrange the shapes on the pocket, and iron into place. Sew small stitches around the heart shapes to secure.

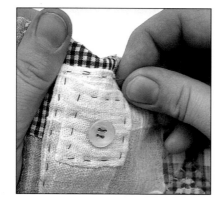

6 Pin the pocket into position on the background fabric and stitch with small running stitches along the three edges.

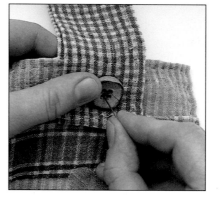

7 Cut two pieces of checked fabric 2 x 10 inches (5 x 25 cm) for the straps. Pin and hem the edges.

Stitch the straps in place at the top of the hanging and sew a wooden button onto each strap.

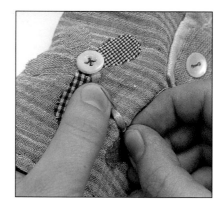

8 Iron the shapes in place on the background fabric and secure with small stitches, then sew a button at the center of each flower head. Cut a length of braid or ribbon for the flower stalks and couch it onto the background.

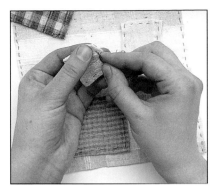

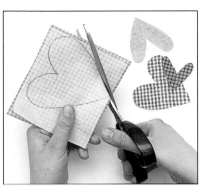

3 Use a piece of cream-colored fabric 7½ x 8½ inches (19 x 22 cm) for the pocket, and cut out several small squares of either cream-colored or a contrasting fabric as patches. Hem the top edge of the pocket, and pin and baste the other edges and the patches. Stitch the patches to the pocket and then remove the basting stitches.

4 Select fabrics for the heart motif and iron fusible bonding web onto the reverse side. Draw the heart shapes in pencil on the paper backing and cut out.

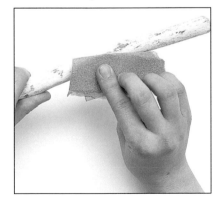

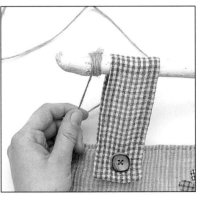

9 Back the hanging with a piece of cream-colored fabric.

Now you will need to paint a suitable stick with latex (emulsion) paint and when it is dry, sand it to achieve a distressed look.

10 Wrap a piece of string around each end of the stick to form a loop to hang it up with.

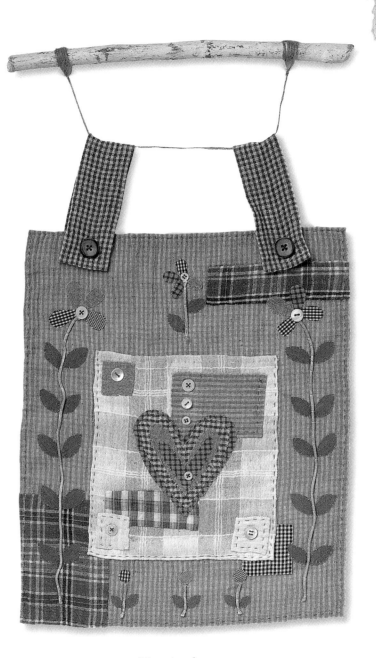

Hanging heart

s a l l y b u r t o n

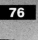
The finished book should be fully functional as a sketchbook or notebook, and is an unusual and highly personal gift.

Book cover

For this book cover another heart design has been used, but you can choose any design which may suit the content or purpose of the book.

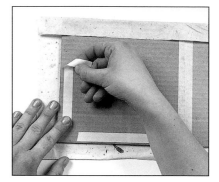

1 Cut two pieces of thick cardboard 6½ inches (17 cm) square and tape them together using masking tape. Make sure they can fold easily.

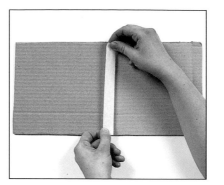

2 Using handmade paper, cover the outside of this cardboard cover. Cut six lengths of double-sided sticky tape about 5 inches (12 cm) long. Attach the strips along the edges of the cardboard cover. Fold the edges over and secure them with double-sided tape.

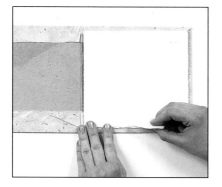

5 Using lengths of double-sided tape stuck onto the outside two pages of watercolor paper, stick the pages into the book cover. Again, don't stick them firmly until you're sure the book will open and close properly.

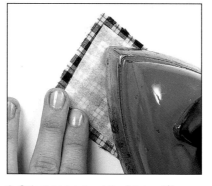

6 Select and cut out the fabrics 4¼ × 5½ inches (11 × 14 cm) to form the base of the appliquéd piece. You will need a piece of brown cotton and a slightly larger piece of cotton check with the edges pinked. Remember, the fabric must fit onto the cover of the book but leave a border of the handmade paper showing.

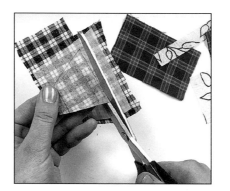

7 Select the fabrics for the flowers, stems, container, and other shapes. Iron paper-backed fusible bonding web onto the wrong side of each one. Using a pencil, draw the shapes on the back of the bonded fabric and cut them out.

8 When all the shapes are cut out, peel off the backing paper and arrange the pieces on the brown-fabric background. Make sure the nonbonded side is facing up, and carefully press with an iron so the bonding web adheres to the background securing the shapes in position.

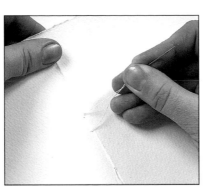

3 Turn the corners in with a sharp crease. When you are satisfied that the cover can open and close easily, fold over the two shorter edges and press firmly onto the sticky tape.

4 Tear a sheet of watercolor paper into four or five rectangles of 6 × 12 inches (15 × 30 cm) of each. If you crease the paper sharply first it should tear easily. Fold these rectangles in half to form pages. Using a strong, white thread, sew them together along the center crease with three large stitches.

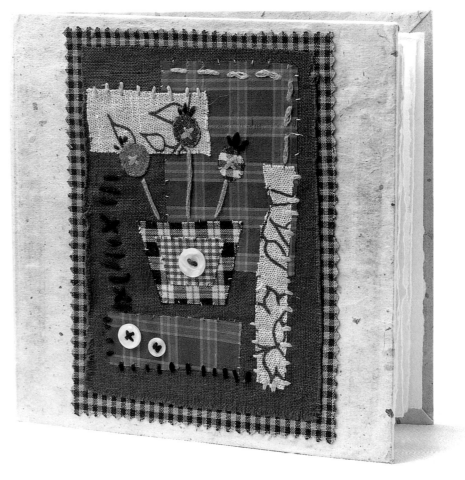

Book cover

sally burton

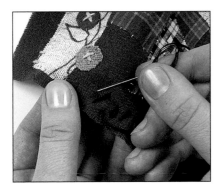

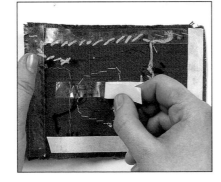

9 Secure some of the shapes with small stitches along the edges of the pieces. Other shapes can be sewn with large stitches and embroidery thread. Use this thread to sew large, uneven stitches on the picture as extra features.

10 Place double-sided tape on the reverse side of the picture's edges and center. Carefully place the picture in the center of the checked fabric background and stick firmly down. Stick double-sided tape along the edges of the checked base fabric. Hold the finished piece over the front cover of the book until it is in position; then press to secure it.

These contemporary pieces use both new and secondhand textiles to create work illustrating dyeing, basic stitching and a variety of cutting and layering techniques. A wide variety of effects can be achieved depending on whether natural fabrics and textures, or manufactured and dyed products, are used.

Gallery

Sue Barry

Dark Side of the Sun

Inspired by Native American drawings, the artist has made use of recycled fabrics, stained canvas and bold stitches to create a simple and balanced design.

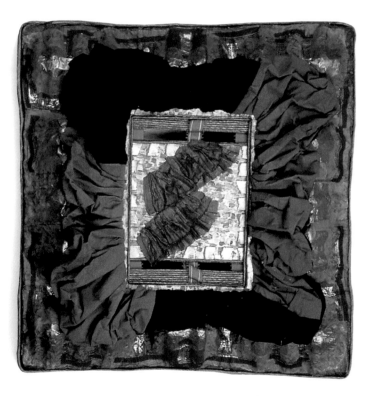

Debra Rapoport

Mirror of Deception

Not all collage work needs to be stuck down flat. Here recycled scraps of fabric have been used to create striking folds, casting shadows over the metallic centerpiece and the semitransparent background layers.

Sally Burton

Collage with Orange Fish

Bold animal motifs have been layered onto panels of checked fabric to create this design. Simple stitching which adds to the naive charm of the design has been included to embellish the animals.

Cas Holmes

Hearts & Flowers (detail)

Structured designs can be very effective. Here the heart has been
layered in rows using a combination of different fabrics. The stitching
in highlight colors cleverly emphasizes the repeated motifs.

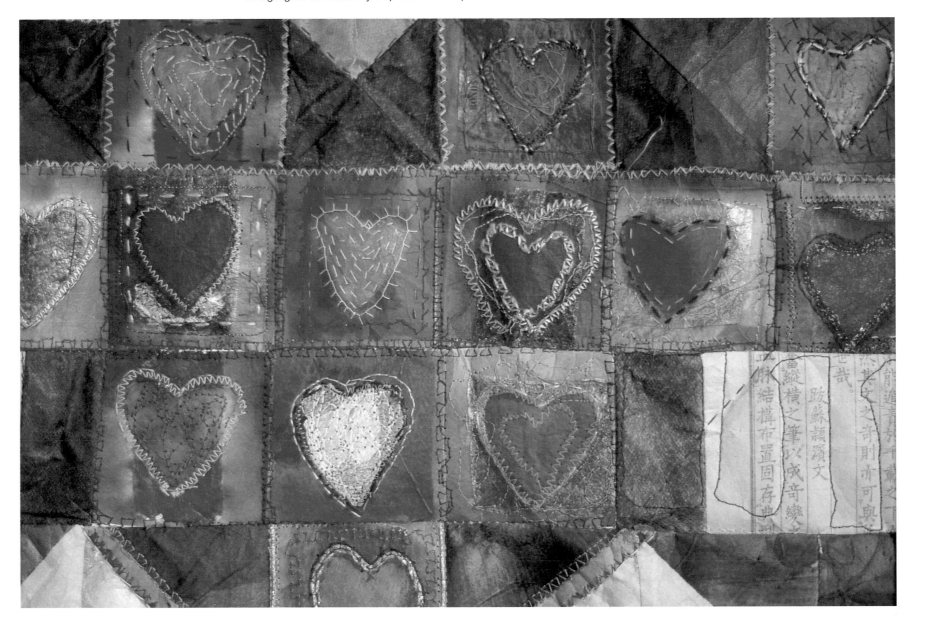

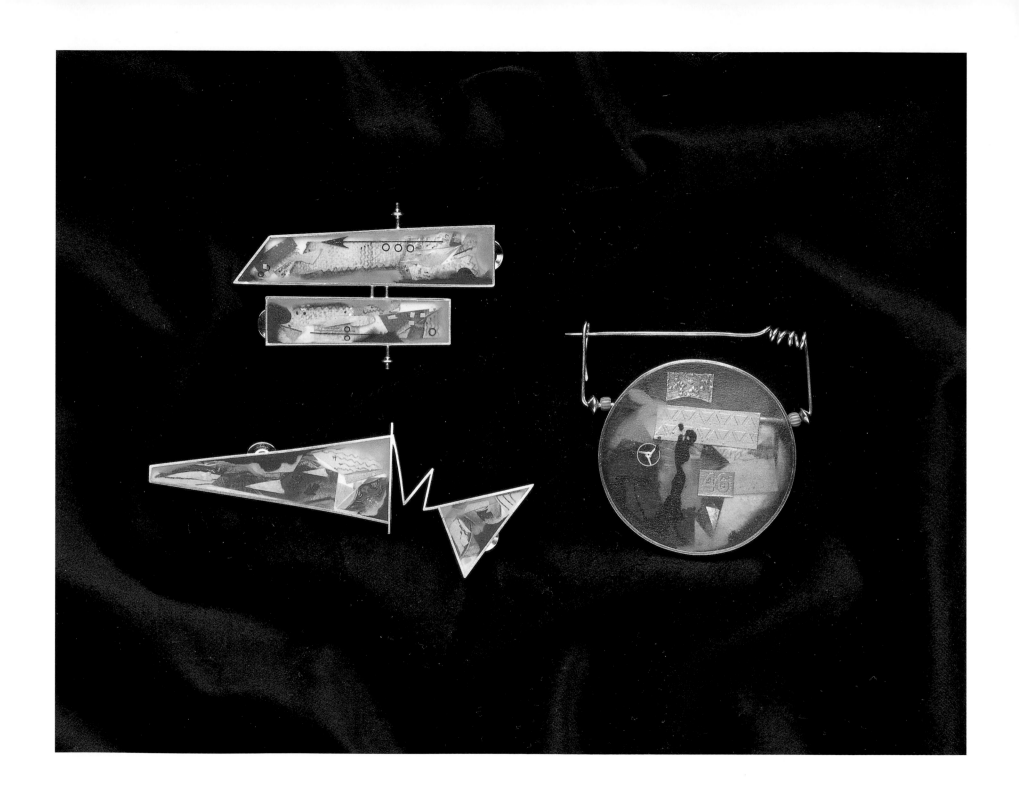

You'll discover plenty of ideas on how collage can add texture and interest to Three-Dimensional objects, as arrangements for your home or for special gifts.

Decorating Three-Dimensional Objects

Making three-dimensional objects, rather than adapting and decorating existing ones, allows greater control over the design. Some aspects of the design, such as the size, may be dictated by function.

Ideas for the general style or shape of an object might come from favorite possessions, images in books and magazines, or a visit to a museum. Starting a collection of postcards, pictures, and sketches will provide an exhaustive supply of ideas.

The addition of embellishments such as handles, rims, and feet can give an object a very different character. If the object is functional, such as a serving tray, serious consideration should be given to the demands that will be made on it – a tray with weak handles is a potential disaster.

This section shows you the techniques to make papier-mâché objects and how to make your own hand made paper to give a very personal look to your collage decoration.

For both of the techniques in this section – making papier-mâché and papermaking – most of the equipment used, such as bowls, scissors, and a strainer, can usually be found in the home.

Materials and properties

If these items are going to be used regularly for papermaking or papier-mâché, it is probably worth acquiring some just for this purpose. However, if they are only going to be used occasionally, provided they are washed thoroughly after use, they will not be damaged. The only special pieces of equipment that might have to be purchased are a liquidizer and a papermaking mold.

plastic wrap (cling film)
Plastic food wrap (cling film), is used as a barrier between the mold and the papier-mâché, without which, they would stick together. An alternative to cling film is Vaseline (petroleum jelly), but it can leave a greasy residue on the papier-mâché.

wallpaper paste
Wallpaper paste is ideal for use with layered or pulped paper.
Note: Most brands of wallpaper paste contain fungicide, so it is advisable to wear plastic or rubber gloves when using this paste. Fungicide-free paste is available from toy stores and specialist craft suppliers.

food processor (liquidizer)
A food processor (or blender) is used to reduce torn, soaked paper to a pulp.
Note: Using a processor (or blender) is a potentially dangerous operation, and children should always be supervised. Because the combination of water and electricity can be dangerous, it is strongly recommended that a circuit breaker is used.

newspaper
Newspaper is usually used as the raw material for contemporary papier-mâché. However, it has several disadvantages to alternative sorts of scrap paper. The first is that all tools and equipment such as the processor or blender, bowls, and hands become coated with a black inky film. The second problem is that when it has dried, it has to be coated with white latex (emulsion) paint to seal in any chemicals that might, over a period of time, affect the surface decoration.

molds for papermaking

Mold acts like a strainer, trapping paper fibers on the mesh and draining the water away. A simple mold can be made by attaching a piece of aluminum-reinforcing mesh to a wooden frame. Any wooden frame will do, provided it is fairly sturdy. The mesh is attached with thumbtacks (drawing pins). Molds should be thoroughly dried after use.

epoxy resin

Epoxy resin is a strong, two-part adhesive used on joints. It is used in this step-by-step project for gluing the feet on the base and for attaching the decorative knob to the lid. It should be mixed according to the manufacturer's instructions, and is not suitable for use by children.

paper and card for papier-mâché

Any paper that is neither glossy nor coated can be used. Typing paper, leaflets, and even junk mail can all be useful sources of the ideal raw material.

cardboard

Corrugated cardboard is used as a basis for layered papier-mâché for constructed objects like the decorated box shown in the step-by-step project.

varnish

Water-based varnish can be purchased from do-it-yourself stores or craft suppliers, and is used to protect decorated papier-mâché objects. It will not discolor handmade papers, and provides enough protection to allow objects to be wiped clean with a damp cloth.

Papier-mâché originally developed as a way of using up scrap paper. The motivation for using scrap paper this way today might be because it is so plentiful, or because of an environmentally motivated concern about recycling.

Using papier-mâché

Several hundred years ago, the motivation for inventing papier-mâché techniques was economic. Papier-mâché was invented as a way of recycling paper which, before the mechanization of papermaking in the eighteenth century, was an expensive and valued material. Papier-mâché factories existed across Europe and later in America, too. They produced a wide variety of items including snuff boxes, dolls' heads, and serving trays. With the mechanization of the papermaking process, paper became less valued, and papier-mâché factories began to close.

Today the attractions of papier-mâché are many, and it has become an increasingly popular medium for artists and craftspeople as well as for students. The materials and equipment are inexpensive, and are often readily available in the home. Scrap paper and corrugated cardboard boxes change from being materials to throw away to an important, and free, supply of materials. When papier-mâché is dry, it is robust and lightweight, making it an ideal medium to use for larger-scale objects that need to be light, perhaps for maneuverability or if perhaps the objects were to be suspended.

Papier-mâché techniques

There are two basic papier-mâché techniques. One involves using torn and layered paper, the other, paper pulp.

Layering papier-mâché

The most familiar method of papier-mâché is to build up layers of paper coated with paste on an existing form or cardboard structure. When the piece is dry, the papier-mâché forms a smooth, thin, rigid surface. The disadvantages of this method are that it is very time-consuming, and that some objects made using the layering technique, such as bowls and plates, are prone to warping. However, it is ideal for using over a cardboard form as shown in the step-by-step box project (see pages 88–89).

Layering

1 Tear the paper into pieces approximately 2 inches (5 cm) square. Mix the wallpaper paste to a smooth consistency. Wearing plastic or rubber gloves smear paste onto both sides of the paper. Place the paper on the box and rub gently to expel trapped air and remove creases.

2 Cover the whole box inside and out with at least four layers of paper.

3 Let the box dry for several days. It will then be rigid and ready to be decorated.

Three-dimensional objects

Both of the step-by-step projects, on pages 88–91, show handmade recycled paper being used as a material for collage, but many of the other collage techniques and materials shown in this book could be adapted for use on a three-dimensional surface. Consider gift wrap, images from magazines, fabrics, and even found objects such as shells and feathers to create different decorative finishes.

Decorating three-dimensional objects with collage

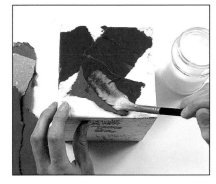

1 Dilute glue with water to a milky consistency. Brush glue onto the box. Apply pieces of paper that are roughly 2 inches (5 cm) square. Brush over with glue. Cover the whole box, carefully covering the edges.

3 Brush the base layer of paper with diluted glue. Place the torn shape on the surface and brush it with paste.

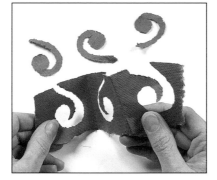

2 Fold a strip of paper in three and carefully tear a decorative shape through all three layers. In this case the artist has made a swirl shape; both the shapes and the negative string of holes can be used to decorate the box.

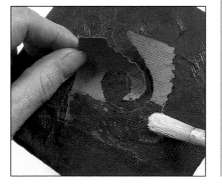

Pulp and paste papier-mâché

The alternative method to layering is to reduce the paper to a pulp and to combine it with paste. The surface of dry pulp-based papier-mâché tends to be bumpy, but for a smooth surface, try sandpapering it. The advantage of using pulp rather than layers is that objects are unlikely to warp; this is worse when decorating with collage rather than painting, as objects become wetter.

Making pulp

1 Tear paper into pieces approximately 1½ inches (4 cm) square. Soak in water for at least 3 hours. Place a small handful of the soaked paper into the processor (liquidizer). Fill with water to the maximum level indicated, and liquidize until the paper is reduced to pulp.

2 Pour the contents of the processor into a strainer to drain the water from the pulp. Agitate the pulp in the strainer to remove excess water. The pulp should be damp, but not dripping.

3 Crumble the pulp to break it up into small pieces. Repeat steps 1–2 until you have enough pulp for your project.

Mix wallpaper paste to a fairly thick consistency. Wearing rubber gloves, gradually add the paste to the pulp.

4 Mix the pulp and paste together until the pulp is pliable, but not wet. When sqeezed into a column 2 inches (5 cm) high, it should remain upright. If it falls over, add more pulp. If it is dry and crumbly, add more paste.

Making handmade recycled paper is easy, inexpensive, and fun. Papers can be custom-made for particular projects, giving greater control than relying on found or bought papers. When the basic technique has been mastered, it can be developed to create an exciting selection of papers.

Papermaking

The method shown here is ideal for making papers for collage. It uses a minimum of special equipment, is easily learned, and sheets of paper can be made quickly.

The quality of the papers may not be quite as high as those produced by more complicated methods, but any uneven edges or irregularities in thickness will probably not be noticeable in a collage. Possible developments of the basic technique might include mixing different-colored pulps together in the bowl or vat of water to make multicolored sheets. To make decorative sheets containing plant materials such as petals or leaves, simply pulp the plants in the processor until they are reduced to pieces of the required size, and add them to the pulped paper in the bowl or vat. Fresh or dried herbs can be incorporated to make scented papers! Experimenting with different materials is fun and results in exciting and unique papers.

Handmade paper is ideal for tearing into shapes to use for collage because, unlike machine-made paper, it has no grain. The torn shapes have an attractive soft edge, although there may be times when a crisper cut edge is more appropriate. Making paper also allows control over the color, texture, and thickness of the paper. Fairly thin papers are ideal for collage on a three-dimensional surface. Thicker papers are more difficult to tear and can lead to a lumpy, uneven surface.

TIP

If a lot of dye comes out of torn paper when it is soaked before it is put in the processor, then it is not colorfast and paper made from it may fade quite quickly. As a general precaution, it is advisable not to place papier-mâché decorated with handmade recycled papers in direct sunlight.

1 Tear colored paper into pieces approximately 1¼ inches (3 cm) square. Soak in water for at least 3 hours.

6 Lay six damp cloths onto a piece of plywood. Turn the mold over so the layer of pulp comes in contact with the top cloth. Keeping your hand flat, press the mesh all over. Make sure that you press into the corners.

7 With a jolting action, lift the mold away, leaving the layer of pulp as a sheet of paper on the cloth.

2 Place a small handful of soaked paper into the processor. Fill with water to the maximum indicated and blend until the paper has been reduced to a pulp.

3 Pour the pulped paper into a rectangular bowl two-thirds full of tepid water. Stir the pulp so that it is evenly distributed in the water.

4 Lower the mesh mold (see page 83) into the mixture of water and pulped paper. Push the mold to the bottom of the bowl.

5 Quickly lift the mold out of the water, trapping a layer of pulp on the mesh. Gently tilt the mold to drain away excess water.

8 Cover the sheet of paper with a flat, damp cloth. Repeat steps 4–8 until the required number of sheets has been made. Add more pulp as necessary. When enough sheets have been made, place the second board on top of the stack of papers and cloths. Press the stack using clamps or by standing on top of it.

9 Carefully peel apart each cloth with a sheet of paper on it. Place on sheets of newspaper and leave to dry overnight.

10 When dry, peel the paper away from the cloth. If the paper has crinkled, it can be pressed under a pile of books or ironed very carefully.

TIP

Pulped paper can be stored in a plastic bag in the refrigerator for several weeks, so you can prepare it in advance, or save leftover pulp for future use. Always store the pulp before paste has been added.

This brightly-colored trinket box shows that decorating objects with collage can be a fun way to make a highly-individual gift.

Decorating a box

Although you could apply the collaging techniques shown here to almost any old, or plain objects you may already have around the home, it's "double-the-fun" if you make the box yourself, too.

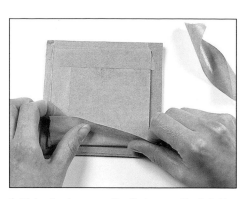

1 Make the box, see the tip box on the left. To make the lid cut one 4¾ inches (12 cm) square and one 4¼ inches (11 cm) square from a sheet of corrugated cardboard. Cut 4 triangles with the height and base both measuring 4½ inches (11.5 cm). Using gum strip (brown paper tape), attach the smaller square to the top of the larger one.

TIP: MAKING A BOX

Cut three pieces of corrugated cardboard 4¾ inches (12 cm) square and two pieces 4½ × 4¾ inches (11 × 12 cm). Tear 8 pieces of brown paper tape 4 inches (10 cm) long. Using a damp sponge, apply water to the shiny side of the tape. Use one of the large squares as the base. Tape the other pieces to the base to form a cross with pieces of cardboard of equal size opposite each other. Lift each side of the box to a vertical position and tape the corners. Rub the tape until smooth, being careful not to push in the sides of the box.

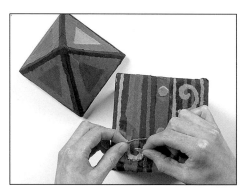

4 Cover the four sides of the box with strips and torn shapes. Paste under and over each piece of paper (see *decorating* on page 85). Decorate the box using the same technique. You may want to collage the base and inside of the box, too.

5 To make the feet cut two bottle corks in half. This is quite tricky; always take great care when using craft knives. Cut a third cork in half to use as a knob on the top of the lid. Cut or sand it to a ball shape and add an indent, to about half its depth, in one place, so that the ball will sit on top of the pyramid.

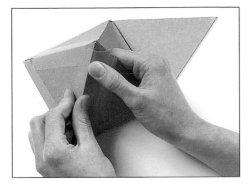

2 Turn the squares over so that the smaller of the two is face down. Tape the triangles to the base. Lift up the triangles to form a pyramid and tape along each adjoining edge. Cover the pyramid with layers of pasted paper see *layering* on page 84. Leave to dry for several days.

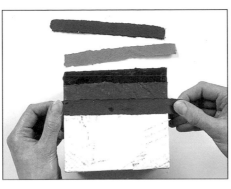

3 Tear the dark blue purchased or handmade paper (see *papermaking* on pages 86–87) into strips ¾ × 5½ inches (1.5 × 14 cm). Brush glue, diluted with water to a milky consistency, onto the box. Apply the strips of paper. Carefully glue one end over the edge and the other end onto the base.

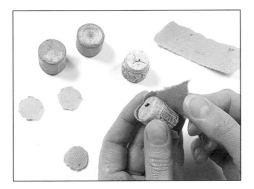

6 Tear a strip of paper slightly longer and wider than the cork. Brush the paper with undiluted glue and wrap it around the cork. Cover one end of each half-cork with a circle of pasted paper.

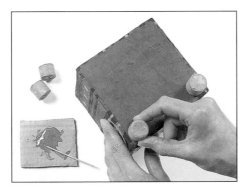

7 Mix epoxy resin (see page 83) according to the manufacturer's instructions. Apply it to the uncovered end of each cork and position one at each corner of the base of the box. Apply glue to the top point of the lid and press on the indented cork. When the glue is dry, seal the box using a water-based varnish.

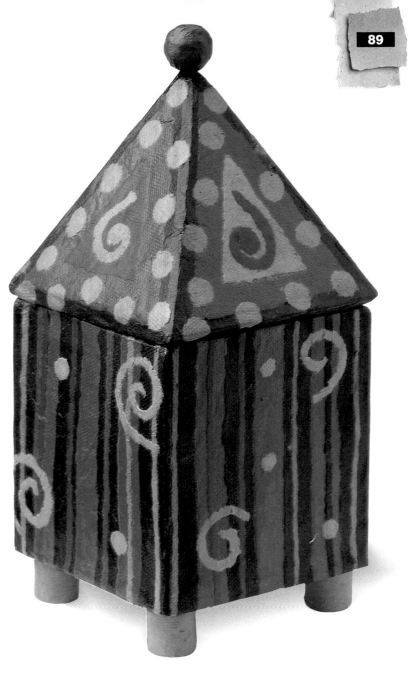

Decorated box

gerry copp

This project would make a lovely ornament for display, but could also be used to hold light, dry items once it is varnished.

Papier-mâché plate

You'll have great fun making this plate and decorating it, too! Here, neutral shades have been used but, you can use differently colored papers to change the plate to suit your own color scheme.

1 Cover the plate with plastic wrap, stretching it to remove creases. Make the pulp as shown on page 85. Wearing plastic gloves, cover the plate with pulp, leaving a rim around the edge of the plate uncovered.

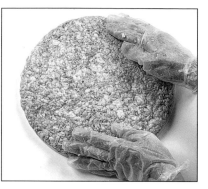

2 When the pulp is about ⅓ inch (1 cm) in depth, rub until smooth. Let it dry for about a week. When completely dry, pry the pulp away from the plate. If necessary, trim the edge of the plate with a sharp pair of scissors.

TIP

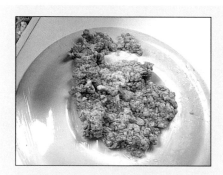

Add the paste to the pulped paper gradually. If the mixture becomes too wet and slides off the mold, add more pulp. A crumbly mixture indicates that not enough paste has been incorporated.

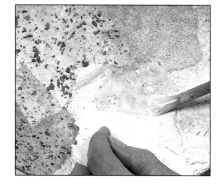

5 Apply pieces of purchased or handmade paper (see *papermaking* on pages 86–87), following the instructions on page 84. Cover the whole plate, carefully gluing the paper over the edge.

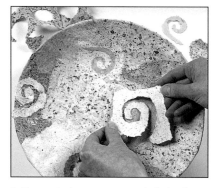

6 Tear spirals, squares, and circles from a variety of papers. Brush glue over the first layer of paper and apply the shapes. Brush over each shape with the glue. When the plate is dry, turn it over and continue to collage papers onto the underside.

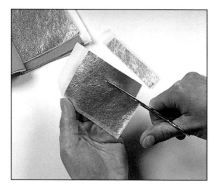

7 When the edge of the plate is dry, it can be gilded. Cut some gold leaf into strips ⅓ inch (1.5 cm) wide.

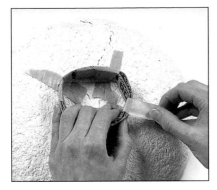

3 Cut a strip of corrugated cardboard 1 × 18 inches (2.5 × 45 cm). Bend to form a ring 4 inches (10 cm) in diameter. Using brown paper tape, secure the ring to the base of the papier-mâché pulp plate.

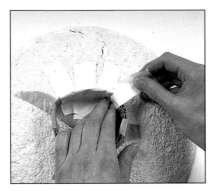

4 Cover the ring with strips of paper smeared with wallpaper paste or glue (see *layering* on page 84).

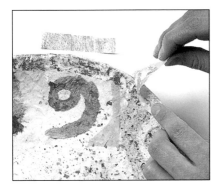

8 Brush undiluted glue around the rim and leave it until it becomes tacky. Gently press the strips of gold leaf onto the glue. Peel away the paper backings, leaving pieces of gold on the rim. Continue around the rim.

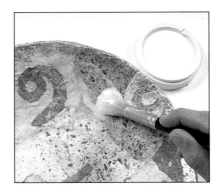

9 When the plate is dry, seal it using a water-based varnish. This will protect the papers and the gold, but will not make the plate waterproof, so only use the plate for dry produce, such as pot pourri.

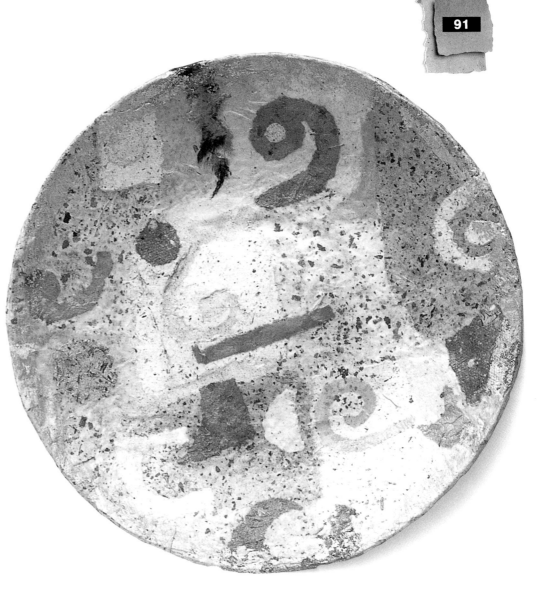

Papier-mâché plate

gerry copp

This striking collection illustrates how a variety of objects can be used as the basis for individual pieces. Techniques employed include using photocopied images and the layering of objects. The scope for working in relief, rather than on a purely flat surface, becomes very exciting in three-dimensional collage work.

Gallery

Jacqueline Myers

Reversible Fibula Pin

Layers of gold foil, paint, etched metals and found objects make up this exquisite pin. The color and position of each element is carefully considered before being used to create a small picture within a piece of jewelry.

Joan Hall

Sisters

A shallow wooden toolbox becomes the base for this nostalgic work. The technique of layering has been cleverly used with the placing of a length of curled rope and a photograph over mirrored glass, giving the piece a greater effect of depth.

JoAnna Poehlmann

Time Table for a Biological Clock

Enlarged and photocopied text has been randomly combined with images inspired by old medical books to produce this stunning piece of sculptural collage.

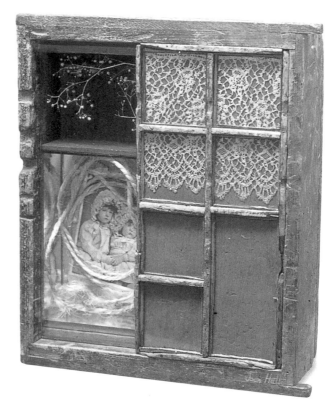

Jean Davey Winter

Memories of Thailand IV

A trip to Thailand inspired this intimate and richly decorated box. Paint has been applied to layers of paper and to found metal and wood surfaces to create a variety of different textures.

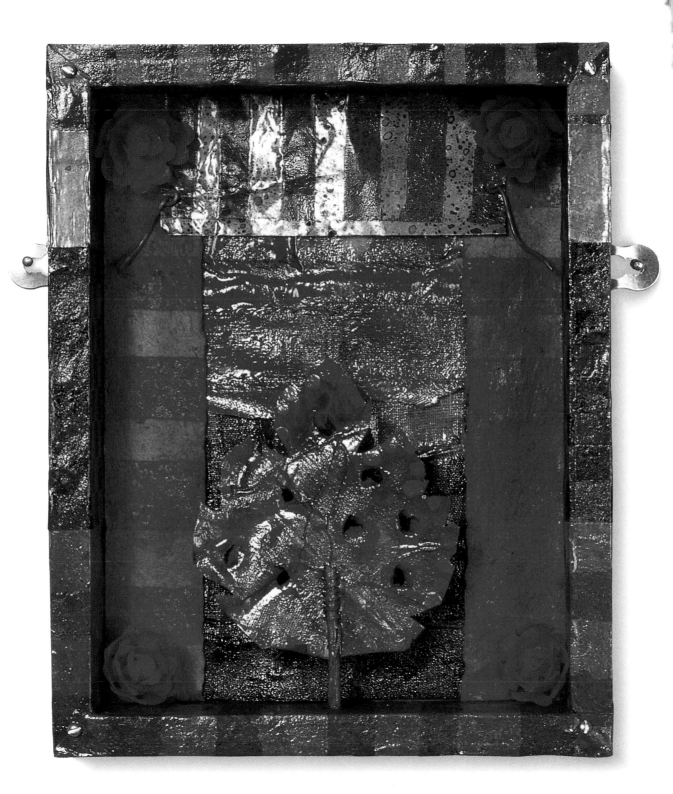

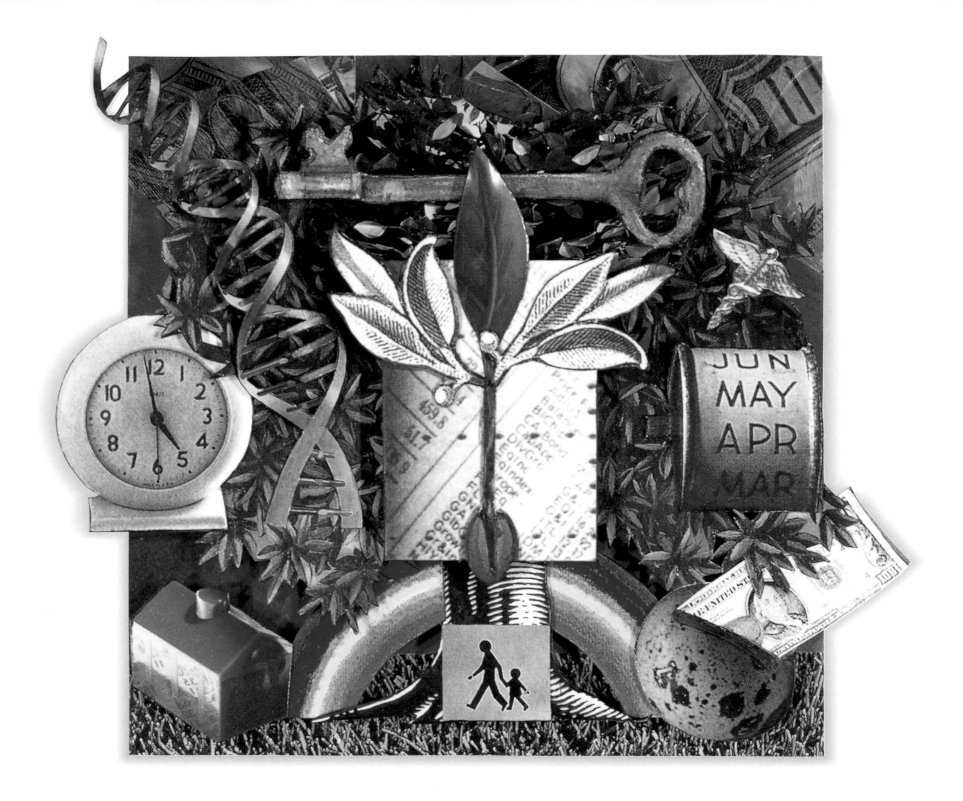

*Découpage is accessible to everyone, and as it requires
very little in the way of special equipment, it is
ideal for beginners.*

Découpage

An ideal starting point for découpage is to revamp old objects around your home using paper
images you have on hand. With a little thought old items such as lampshades, small
cupboards, and boxes can be given a new lease on life. Items that are going to be used around
the house will need to be sealed with varnish to protect the pasted images.
A great variety of images, contemporary as well as traditional, can be used for découpage.
Keep a collection of stamps, greeting cards, paper money, wrapping papers, and
magazine images ready for use.
You can give your work an individual touch by adding color to black-and-white copies or
prints. Use watercolor paints, pencils, crayons, or colored inks. Images with strong black
outlines are particularly suitable as it is easier to color the images neatly. Before you use these
images in découpage, they may need to be sealed with the appropriate fixative
to prevent the color from running or bleeding.
This section shows you that the composition possibilities are limitless. Experiment with
different sizes of images and try creating borders, symmetrical designs, and random patterns
with fragments of images. You can also try manipulating the size and appearance
of your images using a photocopier.

Traditional découpage work aims to paste images flat onto an object and create an even, flat surface – usually by building up layers of varnish on the finished object.

Materials and properties

A host of prepared paper images can be used in découpage projects. Many things are available around the home, such as discarded wrapping paper and stamps. Others, such as copyright-free sheets of découpage images, can be bought.

Magazine and newspaper images

Glossy magazines are an excellent source of découpage imagery. Many other periodicals, supplements and special publications, such as science or nature magazines can also be useful sources. Newspapers can often offer an ideal solution for backgrounds and areas which need to be covered with texture. Foreign-language newspapers are especially good as the text creates interest but does not need to be read.

special sheets of designs
Commercially produced sheets of copyright-free designs are often useful. Many of them show the more traditional, particularly Victorian, images. One of the main benefits of using such sheets are that the images are well separated and easy to cut out.

careful cutting
Images used in découpage need to be cut out carefully before you position and glue them down. One of the most effective ways of cutting out images is to use a craft (mat) knife. Always use a cutting mat and keep your fingers away from the blade.

wrapping papers and paper bags
Wrapping papers are an excellent source of material. There are a multitude of contemporary designs to choose from covering every subject imaginable. Choose good-quality, thicker papers, with shapes which can easily be separated when cutting.

paper quality: thin paper
Although thinner, more translucent papers are more difficult to work with, they can give interesting effects. For example, the background quality of wood may show through when it is covered with a translucent paper image pasted in place. Experiment before using thinner papers on your finished objects; sometimes any images from the reverse side of the paper show through on the front and ruin the design.

sheet music, stamps and paper money

This source of images is almost inexhaustible. Any paper images can be used – foreign paper money left over from a vacation, stamps, and old letters provide excellent textures and colors for a starting point.

old greeting cards and post cards

Greeting cards and old Christmas cards will be readily available in most homes. Keep a variety of designs; look especially for interesting border designs. For a different approach, consider using the message side of post cards showing the writing.

tearing

Another way of cutting out images is to tear carefully around the edges of the image. This method is less precise, and leaves a unique, rough-edged quality.

paper quality: thick paper or cardboard

Give thought to the preparation of images to be used. If you are using post cards or greeting cards, the thick paper backing may need to be removed. Soak the card in warm water, then gently peel the image off the backing paper. Leave the image on an absorbent cloth to dry thoroughly before using it in your work.

relief surface

Another technique, appropriate for objects which do not need a flat surface, is to attach the images in relief (sticking up from the surface). This technique is particularly suitable for box lids and pieces which will not be handled often; it should not be used on items that require varnishing.

Remember that you cannot place things on top of relief designs as the shapes will be squashed.

For many, the interest in découpage lies in the fact that old objects such as cupboards and boxes can be transformed. Garage sales, secondhand shops, and attics become a source of such items to use as a base for découpage work.

Preparation and altering images

The objects you choose to use may need tidying up with a painted background. Make sure the object to be painted is clean and dry. Remove traces of old paint with coarse sandpaper, then lightly sand the surface with fine sandpaper and wipe clean with a damp cloth.

"Blanks" are unfinished objects and furniture items, such as boxes, bowls, magazine racks, tables and coat stands, manufactured for découpage and other crafts. They may need a coat of primer before your chosen top coat of paint.

Painting your object

Apply paint in regular strokes using a large brush. Try to avoid painting over the same area more than once as this leads to an uneven surface. You could also try applying the paint to the surface using rags, sponges, or different brushes.

More advanced paint effects such as distressing can be achieved by sanding a thinly painted background after it has dried. You could also try mixing a second color to a watery consistency and applying it on top of your base color. The second color should be thin enough to allow the base color to show through.

A colorwash paint effect can be achieved by using a cloth to apply this watered-down second coat. Work the paint in randomly and cover the whole surface.

How to paint your object

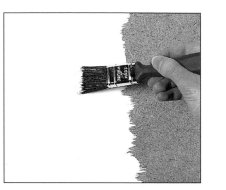 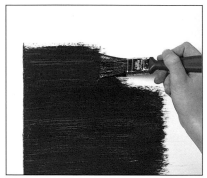

1 This blank firescreen made from hardboard was primed using white acrylic primer. Use a wide brush and work with steady, even strokes.

2 When the primer is completely dry, paint the top coat, again using a wide brush in even strokes. Here the artist has used a bright red acrylic paint.

Altering images: photocopying

1 Here the original image has been enlarged by 150% and 200% and reduced by 50% and 75%.

2 The original image has been stretched widthwise. Images can also be stretched lengthwise. This feature is particularly useful if you want to make your image fit into a certain area of your design.

Altering the appearance of images

Current photocopier technology allows the découpage artist to create a huge variety of different images from the original picture. Always use copyright-free images or obtain the permission of the copyright holder before photocopying your images.

The most simple alteration you can try is reduction and enlargement of your image. Take a variety of copies in different sizes so you can see which best fits your design. You could also ask the photocopy shop to repeat images across the page, stretch the image sideways or lengthwise, or reverse the colors in a negative copy.

Cutting and tearing

The effect of your final découpage design will depend upon which method you choose to cut out your images. Cutting gives a precise, clean edge, whereas tearing has a more random, subtle edge quality. Images can be trimmed close around their outlines, or you could choose to give them a random edge following your own design. If you like one particular aspect of an image, you can cut or tear around it selectively. For example, a central image can be removed from its existing border so you can add your own.

If you have several identical images, cut and tear them in different ways, experimenting until you find the most appropriate result for your work.

Cutting using scissors

1 Scissors can be used to cut bold shapes with clear edges. If you have a sheet of images, cut each image away from the background leaving a wide margin. Then trim each image individually. Move the paper with your free hand, rather than trying to move the scissors.

Cutting using a craft (mat) knife

1 Awkward and delicate shapes can be cut accurately using a craft (mat) knife. Be sure to place a cutting mat underneath the image. Use one hand to keep the paper steady, making sure you keep your fingers well away from the blade.

2 Use a metal ruler when cutting borders and straight lines. As before, use a cutting mat and keep fingers well away from the blade.

Tearing images

1 An attractive edge quality can be achieved by ripping around your image. Draw a pencil outline around the shape to be ripped out. Erase this line before gluing the image in place. Here the artist has ripped the paper to reveal the chamfered edge (see page 14).

One of the most enjoyable things about découpage is that you can adapt your own images or other preprinted material and make them suit a fresh, new project.

Attaching images and adding color

Attaching images to a base object

A variety of adhesive products can be used to attach images to your base object. Choice of adhesive will depend on the surface on which you are mounting your image. White craft glue (PVA) or wallpaper paste will be suitable for most projects. When using wallpaper paste, mix it to a thin consistency and apply to the base object in the place where you want the image to sit. Then add the image and smooth into place. White craft glue (PVA) should be watered down to a creamy consistency and can be applied directly to the back of the image. When the image is stuck in place, carefully wipe away any excess glue with a damp cloth or sponge.

Other adhesives

Use double-sided adhesive pads to mount onto fabric. If they lose their stickiness over time, the old pads can easily be removed and fresh ones put in place without causing noticeable damage to the fabric. In some cases a dry glue stick could be used. Some of the dry glues available are less permanent, so if an object is to be used widely, a more permanent glue might be more appropriate.

Gluing down paper images

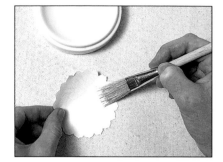

1 Prime your base object and then apply a top coat color. Here the artist has used sandstone yellow water-based acrylic paint. Let the object dry.

2 Cut out the image to be applied using scissors or a craft (mat) knife. Mix a little white craft glue (PVA) with water to make a creamy consistency. Place some scrap paper underneath your cutout. Apply glue to the back of the image – not too much or it may leak out to the front.

Using watercolor paint

Using colored pencil

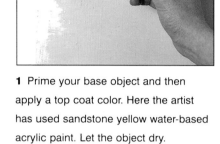

1 Mix paint to a watery consistency and apply it to the photocopied image with a small brush. Mix colors in a palette and always use clean water.

1 Two or three different colored pencils can be used to build up a graduated or textured effect. You could also try watercolor pencils applied like an ordinary pencil, with water then brushed on to give a subtle watery paint finish.

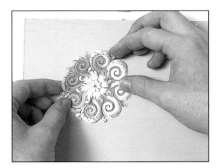

3 Turn the glued image right side up and lay it on the primed, painted background. Press firmly in place. Wipe away any excess glue with a damp sponge or cloth.

1 Add ink to a photocopied image with a small brush. Water-based inks can be diluted to produce lighter shades or mixed to give a wider variety of colors.

Adding color to a black-and-white image

Basic black-and-white photocopied images can be made more interesting by the addition of color. Your work will become more personal and individual if you decide your own color schemes and experiment with different color ideas. Always take a few more copies than you think you need to allow for mistakes when adding paint or ink.

Coloring mediums

The choice of mediums used to add color to images is up to you and will depend on the effect you want in your work. A watery paint effect gives a light feel and is effective with delicate images. Dark inks can be used to give bold color and work well on simple designs. Colored pencil can be used to give textured effects, especially if you create pencil strokes in different directions. Experiment with different mediums until you are familiar with the characteristics of each method.

If you do not have a steady hand, practice on spare photocopies. Have a paper towel handy in case of drips – you may want to keep the water palette and paint or ink bottles away from the photocopied images to avoid the risk of spillage.

Finished effects and varnish

If you want to be able to use your projects around the house, you will need to seal the item with several coats of varnish. Polyurethane and acrylic varnishes are both suitable. A specialist crackle varnish (cracklure) can be used to give your work an aged appearance. It is best to coat a finished object with several layers of varnish. At least five is preferable; the more layers you apply, the longer the surface will be protected.

1 Prime and paint the surface of your object. Here the artist has chosen creamy white for the top color. When the paint is completely dry, apply the first coat (stage one) of crackle varnish according to the manufacturer's instructions. When the first coat is dry, apply the second coat (stage two), taking care not to go over the pattern on the box itself.

If the varnish seems too thick and sticky, place the closed pot in a shallow dish of warm water for a few minutes.

2 When the varnish has dried, brush on a thin coat of black artist's oil paint. Work quickly, and try to avoid covering any area more than once.

3 Use a rag to wipe off the surface oil paint, leaving paint in the cracks. Have plenty of clean rags handy, and discard each rag as soon as it is soiled. Continue until the surface is clear of paint. Do not use mineral spirits (white spirit) on the rags because the solvent will dissolve the paint in the cracks.

Any flaws in the effect can be drawn in using a fine brush and some of the same oil paint.

4 The finished crackle glaze, giving a new surface a subtle aged look.

An old box can be given a new life and turned into an attractive storage item with just a little thought. If you do not have old objects which can be revamped, look out for plain new boxes, small cases, or folders, all of which can be used in the same way as a base for découpage.

Japanese box

Choose a selection of sheets of bright paper. The artist has used embossed Japanese paper with lots of gold in the design. Try to find at least six different patterns so that your finished design will have a variety of colors. The sheets of colored paper are cut into squares, and random shapes are then created by cutting across the diagonal of each square.

Always use a metal ruler when cutting with a craft (mat) knife and keep fingers and thumbs well back from the cutting edge. Since glimpses of the background will show in between the paper shapes, you will need to paint the wooden or stiff cardboard box before starting work on the découpage. A dry glue stick is used to attach the shapes to the box and the final design is varnished, making it suitable for use around the home.

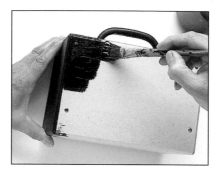

1 Lightly sand the surface of the box to remove traces of dirt and old paint. Clean the surface with a slightly damp cloth. When the box is dry, paint it black using a water-based acrylic paint. Be sure to brush the paint on evenly to ensure a flat surface. Let it dry thoroughly.

2 Using a metal ruler and a sharp craft (mat) knife, carefully cut each sheet of paper into strips. If the paper is thick, the first cut may only score the surface of the paper, and not cut it. If this happens, keep the ruler in place and cut along the same line several times. Let the tools do the work, not brute force.

Using the metal ruler and craft (mat) knife, cut each strip in turn into squares all of the same size.

5 Paint the inside of the box with white latex (emulsion) paint. Use a flat, fairly stiff brush so you can paint right into each inside corner.

6 When all of the shapes have been securely attached, the handle can be decorated. Using a small brush, paint the handle with black latex (emulsion) paint. Once the paint is dry, add a coat of crackle varnish and let it dry.

3 Carefully cut each paper square into smaller shapes. Here they have been cut into triangular shapes by cutting across the diagonal, slightly off center. Cut across each square in one swipe to avoid ragged edges. If the paper is thin, cut several squares at once by stacking them on top of one another.

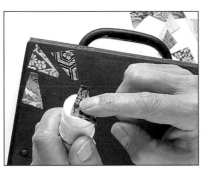

4 Begin to attach the cutout shapes to the dry painted box. Cover the back of each shape in turn with glue, lay in place on the surface of the box, and press down firmly. A dry glue stick has been used here as it is quick and does not leave glue on the front of the shapes.

Arrange the shapes randomly, leaving space between each cutout shape to show the black background.

7 When the crackle varnish is completely dry, add a coat of white latex (emulsion) paint. Avoid going over any area twice, as this will disturb any cracks which have begun to appear as the paint dries.

Varnish the dry handle at least twice, letting each coat dry thoroughly before re-applying.

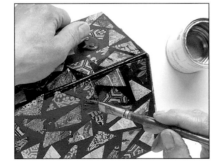

8 Varnish the completed box once the handle is dry. An oil-based varnish, applied in a well-ventilated area, will protect the shapes and can be cleaned. A clear varnish which does not dull the colors of the paper, produces a high gloss finish to give the box the appearance of Japanese lacquer. Leave to dry and apply a second coat.

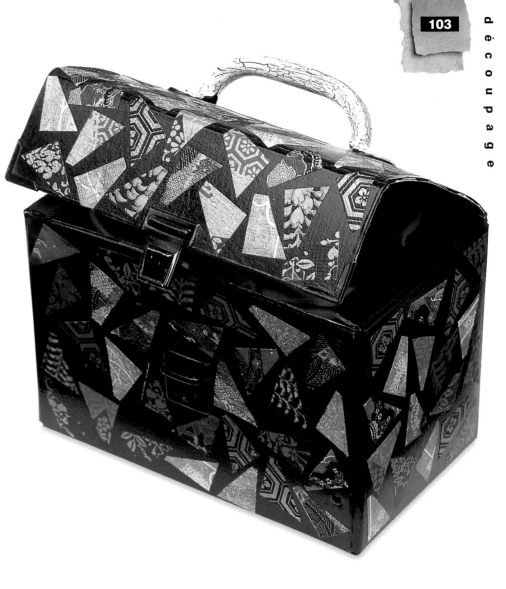

Japanese box

graham day

Liven up a plain lampshade with a pretty and original découpage design. Choose a subject to fit into your color scheme.

Butterfly lampshade

The butterfly images are printed with black outlines and blocks of plain color that are ideal for this project. Most bold images would be suitable for this project, provided they are printed so you can easily cut around the edges. If the project is to be given as a gift, take care if you choose insect images – some people don't like moths, beetles, spiders or dragonflies.

Simple and easy to complete, this project requires little in the way of special materials. You need a lampshade, double-sided adhesive foam pads, old black broom bristles, and some colorful cutout images. Take care to create a clean edge when you cut out the images. The double-sided pads can easily be cut to size, so they are ideal for securing the butterflies and the antennae. The finished result is a lively lampshade which looks as if a host of colorful butterflies has just landed. The shade can be cleaned using a small soft-bristled brush to carefully brush away dust from on top of and behind the butterflies.

1 Using sharp scissors, carefully cut around each image. Keep the scissors stationary and move the paper around. Cut the shapes cleanly, and slightly overcut into the indentations to avoid leaving ragged white edges. Cut out images of different sizes to give your finished lampshade a balanced feel.

3 Try the pad and antennae for size on the back of one of the butterflies. If the pad is too big and protrudes over the edges, cut it down until it is small enough to sit on the back of the cutout butterfly without being seen from the front. Peel off the protective backing and attach the foam pad and the bristle antennae to the back of the butterfly, making sure the antennae stick out realistically. Note that the antennae and the butterfly body are on opposite sides of the pad.

Repeat this step for all the cutout butterflies, varying the length of the antennae for a more realistic effect. Place each butterfly right side down on a clean surface until you are ready to start sticking them onto the lampshade.

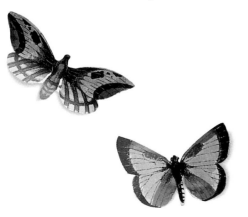

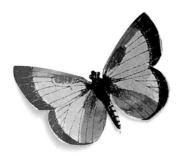

2 To give the cutout butterflies a realistic feel, add some antennae made from black broom bristles. Cut the bristles 2–3 inches (5–7.5 cm) long and separate them. Select one bristle at a time and bend it in half. Attach the bent area of the bristle to one side of a square double-sided adhesive pad. Do not remove the backing paper from the other side of the pad.

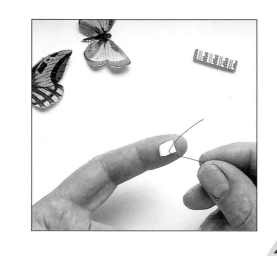

4 Carefully attach the sticky side of the pad (with antennae) to the lampshade. Press firmly with one finger inside the shade and one outside to make sure the butterfly is well stuck. Attach all the completed butterflies to the surface of the shade. Place them in a random way, trying to maintain a balance of color and a variety of sizes. When all the lampshade has been covered, bend up the wings of some of the butterflies slightly to give the appearance that they have just landed or are about to take off.

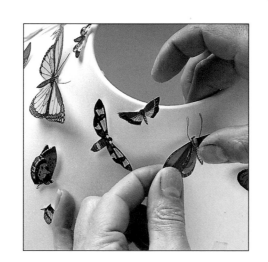

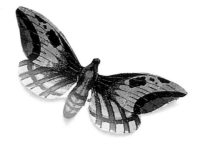

Butterfly lampshade

g r a h a m d a y

Four very different examples of découpage are showcased in this section, each demonstrating the transformation of everyday objects. Some of the work has been made by applying cutouts to a painted background on the base object. On other pieces, the découpage work completely covers the base object.

Gallery

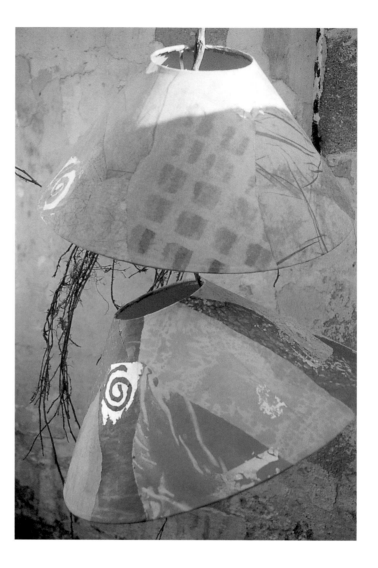

Deborah Schneebeli-Morrell

Wastepaper Basket

Mementos from vacation trips can be an effective source of découpage material. Here the artist has used foreign money, tickets and receipts to create a personal design on a wastepaper basket.

Andrea Maflin

Blue & Orange Swirls

Decorative and handmade papers have randomly been ripped and layered over lampshades. The artist has added swirl motifs in gold leaf to create the finishing touches.

Deborah Johnson

Young Lovers

An ordinary galvanized household bucket has been transformed into a decorative container. Traditional English Victorian imagery of figures make a romantic subject for the main body of the bucket, while layers of flowers and feathers make an attractive border.

Stewart Walton

Gardening Box

Cutouts of garden implements, colorful flowers and bulbs have been pasted onto a matte black background and cleverly folded around the corners of the box making a stunning final product.

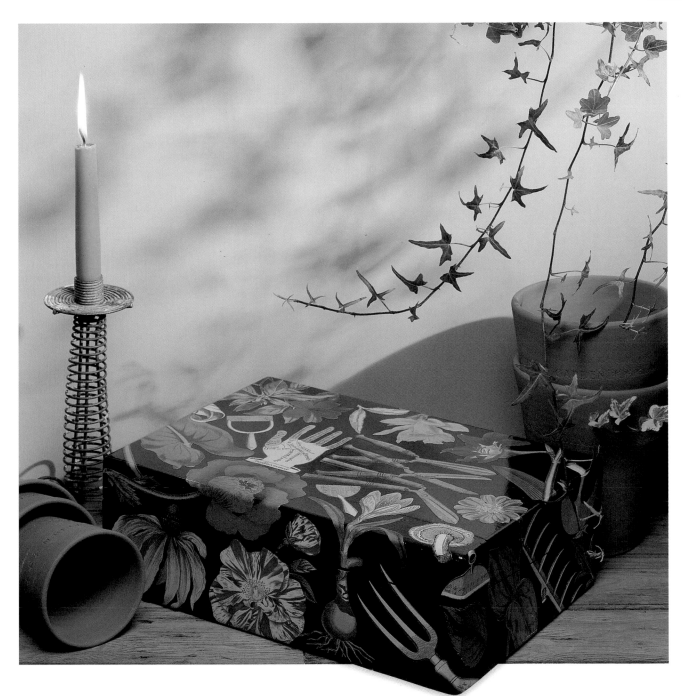

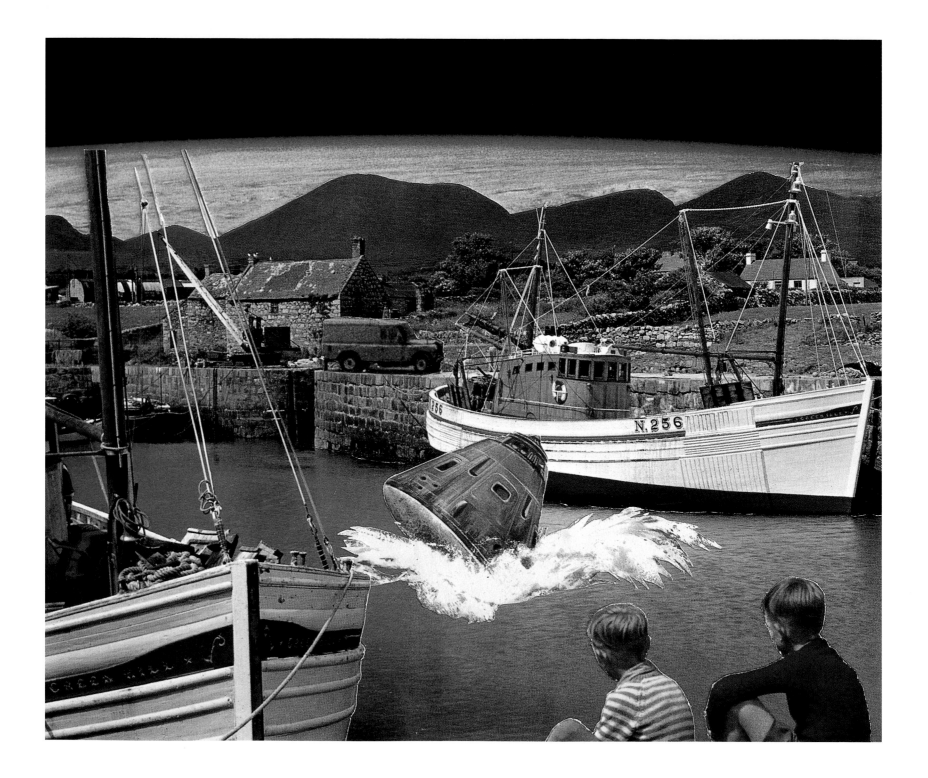

If you enjoy photography and acquire hordes of photographs which never find their way into albums, why not use them to experiment with photomontage to create new and exciting images.

Photomontage

Photomontage involves the manipulation of the photographic image and is as old a practice as photography itself. The history of the art form dates from direct contact printing of real items such as leaves and flowers, through to double exposures, and finally to cutting out and reassembling photographs. Now with the abundance of the printed image, it is not necessary to take your own photographs, and the invention of the photocopier allows infinite manipulation of any imagery you may find. The basis of the photomontaged image depends on the qualities of the component imagery and how they are used.

Because a found image has been produced by someone else, it could be subject to copyright laws. However, for the purpose of personal use, as long as your work is not reproduced for the public domain, copyright laws will probably not apply to you. Generally, it is best to use only small and unrecognizable parts of images and treat them in such a way that you make a new and fresh work from them.

This section shows you many of the techniques on how to manipulate and assemble images for amazing results.

A library of pictures can be compiled from a variety of sources such as newspapers, books, cards, packaging, magazines, and your own photographs.

Materials and properties

Photo research and selection
To produce an image, find or take pictures bearing in mind the subject matter of the final product and the mood, tone, focus, color, and so on. For example, use warm colors for happy subject matter. The pictures may be landscapes, portraits, or an abstract.

If you take images from printed material, such as books and magazines, you must keep in mind that the copyright of the images is protected and such images should not be used in your work – especially if it is intended for commercial purposes. Always seek the copyright holder's permission for use.

photocopying paper
Any papers that can be passed through a black-and-white copier: Tracing paper, copier-compatible acetate, construction (sugar) paper, cartridge paper, writing paper, certain handmade papers (compact and non-fragile ones). All papers should be approved by a photocopy technician before use.

photographic source material
Printed ephemera containing imagery: Magazines, newspapers, books, and packaging.
Your own photographs: Ranging from snapshots to professional photos.
Photocopied images: From the two sources above or from real objects placed on photocopier bed.

cutting tools
Scissors, craft (or mat) knife or scalpel, pinking shears.

photo content and style

Each image can have a different style and content: Age, focus, size, subject, light and dark contrast, color, mood, situation, textures, elements.

distressed surface

A distressed or scratched surface can have movement. The surface can be altered with smudging, new marks drawn onto it, or items removed from it.

photo format

The paper and context of the photo have different qualities, which should be considered. Newspaper is rough and "direct"; magazines are generally glossy and fantasy-oriented. Images relating to these genres will usually carry these connotations into the finished work.

ripped or cut edges

Ripping can give texture whereas scissors give a clean edge. Pinking shears produce zigzag edges.

photo surface

The surface on which the image appears can have many textures and qualities, and it can be changed by photocopying onto different papers to alter the color, mood, flexibility, and focus of the image and work.

adhesives

White craft glue (PVA) and dry glue sticks.

Once you have chosen the subject matter of your work, the next step is deciding on the composition of a piece of montage. After this pivotal decision is made comes the choice of images to be used and their manipulation, bearing in mind focus, mood, color, contrast and harmony.

Manipulating images

A pencil rough can be used to map out the components and where they will go and how they will appear. Color and tone can be added to aid your decision-making process.

The rough can be followed as you arrange and rearrange the parts themselves, but the decision-making process should continue throughout. Changes and additions can be made as you go along according to how the pieces appear when they are actually combined.

Photography manipulation

Taking your own photographs allows flexibility of treatment and infinite choice of subject matter, as long as you can find the things you need to photograph. A specific subject can be photographed in exactly the way you need it according to light, focus, zoom, situation, mood, and color.

The better the quality of your photography, the more useful the images will probably be. But any pictures, from snapshots to professional quality, can be used. Darkroom techniques such as double exposure are useful, but not necessary.

Lighting effects

Experimenting with different types of light – sunlight, lamplight – and different amounts of light, and directional light can give varying effects for photographing a subject.

Directional lighting

1 Equal lighting from both sides has been used to show the object's total surface detail clearly – giving a neutral mood to the object.

2 One-sided lighting has been used for dramatic effect. It allows some surface detail to be visible, but takes advantage of the mood-creating shadow.

3 Backlighting (in this case using a translucent surface which the diffused light shines through) almost totally cancels out surface detail, allowing the silhouette and holes in the surface to dominate the image, thus creating an extremely dramatic and mysterious effect.

Zoom effects

1 Getting close to the subject or scene, or using a zoom lens, allows attention to be directed to a certain area, in this case the eyes of the mask.

1 Placing a layer of gauze (gold-colored here) in front of the camera lens gives a soft focus effect and a gentle color change.

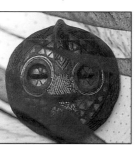

2 Colored netting, falling in folds, is used in front of the object to partially obscure the object. It also produces a colored covering of the object and background.

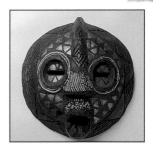

3 Colored cellophane can be used to alter the color of the scene markedly. Special filters can also be used.

Photocopy manipulation

By using a photocopier (color or black-and-white), you can enlarge, reduce, zoom in on, flip, stretch, and compress an image (or even a flat-surfaced object placed on the photocopier bed). Images can be turned from positive to negative, and have their tone and color altered to suit your needs. A photocopier technician can tell you which machines to use and how to achieve these effects. Plan your image (possibly using a rough) and organize the things you will need before you manipulate the component parts on a copier so that you do not waste time and money on copies you cannot use – for instance, because they are the wrong size.

Enlarging, reducing, and repeating an image

Different copiers have different facilities to enlarge, reduce, and repeat an image. A photocopier technician can advise you on how to achieve the results you want.

Flipping an image

Using the mirror-image facility, on copiers which have it, an image can be reverse flipped to suit your needs.

Altering the X/Y axis of an image

Some copiers have an X/Y zoom facility which allows the X and Y axes of an image to be stretched up to 400% and compressed down to 50%, thus creating a change in dimensions of the image.

Enlarging, reducing, and repeating an image

Flipping an image

Altering the X/Y axes of an image

1 A color copier has been used to enlarge the photo to 400% and reduce it to 50%, and to repeat it at 50% four times along an 8 x 10-inch (A4) sheet.

1 The photo on the left has been color-copied using the mirror-image facility to produce the flipped copy on the right.

1 Images produced by (clockwise from left): stretching the Y-axis to 400%; stretching the X-axis to 400%; stretching the Y-axis to 300% and compressing the X-axis to 60%; and using the X/Y zoom.

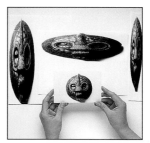

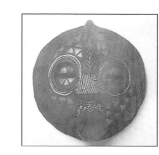

The nature of the background imagery and style of its creation depend on the theme and mood of the overall image you are intending to make: Humorous, surreal, sensitive, realistic.

Creating a background

Once you have decided the nature of the imagery, you can begin to manipulate it and cut it up accordingly. Before you begin, decide on the dimensions of the finished piece, and where the focus will be. Is it a landscape? Is there a certain type of light? Is it all foreground detail, or is there a depth of field and sense of perspective? You can then manipulate and juxtapose imagery accordingly.

Creating a background in strips

If the image you wish to create requires a background of large areas or strips of general or obvious texture, color, or imagery, such as in a landscape, this is the best technique to use.

1 Assemble your photos: In the case of a landscape you want a sky, a background area, and a foreground area. Each element should be distinct enough to give a sense of perspective and separate identity between them, but they need to have complementary qualities in either their color, texture, or lighting to work as a scene.

2 If the pictures you choose need to be trimmed down to the areas of interest, use a scalpel and ruler on a cutting board – with care. Keep arranging the images until you find a combination that appears to work. Then hold layers together with a little glue if there is enough overlap or use a backing of paper or cardboard and glue each layer onto it.

3 If you want the image to have straight edges, use a ruler and draw a light pencil line to mark where you want to trim the image. Remember to bear in mind the desired dimensions of the finished product when drawing cutting lines.

The image can then be trimmed along the indicated lines, using a scalpel with a ruler on a cutting board.

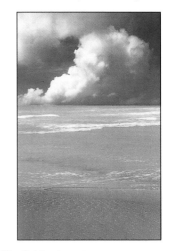

4 The finished product can be glued to a backing of paper or cardboard using a moderate all-over covering of dry glue stick or white craft glue (PVA) across the back.

Creating a background: images of similar color

For this sequence a theme of the color blue has been selected to produce a lively and dreamlike background from random images. Start with a selection of blue images of varying sizes and shapes and experiment with the arrangement, perhaps according to the shade of blue or size or subject matter. Below, the artist has started with the larger shapes and added smaller images on top.

Creating a background: Images of similar color

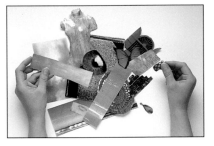

1 Starting with a selection of blue images of varying sizes, shapes, and subject matter, you can begin to work out how to arrange them – perhaps according to shade of blue or size or subject matter.

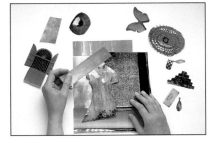

2 Here the largest areas of blue have been laid down, and smaller parts are being added to the basic square shape.

3 An idea of the ways in which the smaller parts can be added to the final piece can be seen here.

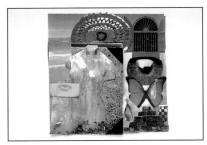

4 The finished arrangement can now be glued together and possibly mounted on a backing of paper or cardboard.

Creating a background: Images with a similar texture

For this sequence the theme of wood textures has been chosen to create a unified background. Images of a similar texture have been collected together and an arrangement is made according to the shape of the background required. Glue the individual pieces onto a backing paper or cardboard as shown in *Creating a background in strips*.

Creating a background: Images with a similar texture

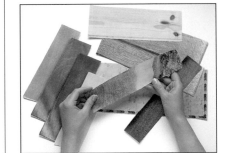

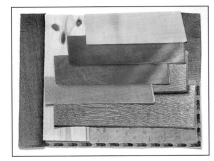

1 Images of similar texture have been collected together so decisions can be made on which ones might go together.

An arrangement is beginning to be made according to the shape of the background required. Once arranged, you may need to attempt several options before finding a pleasing result.

2 The pieces can then be held in place using a glue stick between the layers.

The finished result can be glued to a backing of paper or cardboard using white craft glue (PVA).

TIP

Creating a background: Images with different shapes

A background can also be created in a kind of mosaic effect by combining images of different shapes and sizes. The background can be given a random feel by simply overlaying chosen images or parts of images as you please, but perhaps according to color, texture, tone, and the nature of the images. You can blend one into another or use the images to create a lively and even chaotic scene.

Once you have created a background, the focal point detail can be overlaid. Several layers can go on top of each other, with various parts of each visible from underneath the next. Or there may be only one extra layer on top of the background, or a combination of the two.

Overlaying

Once again, the choice of image to be overlaid will depend on the subject matter, mood, color scheme, and size of the final image – and their manipulation should also be dictated by such things. Different textures (of the image and the paper on which it appears) can be used to complement each other or to create contrast. Some transparent or translucent layers can be overlaid to allow the images below to show through. There should be constant assessment, and new items and techniques may become needed as the work progresses.

Transparent layers

An image photocopied onto acetate allows total transparency in the areas without print on them.

Using transparent layers

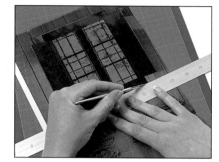

1 Photocopy a window frame onto acetate. Using a scalpel and metal rule on a cutting board, carefully trim it down to the window frame border.

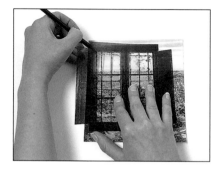

2 Choose an area of landscape that you would like to have showing through the window area, and place the window over it. Holding it in place, mark on the landscape the points where the four corners of the window fall depicting with a cross the horizontal and vertical lines and where they meet.

Using a scalpel, trim the landscape by lining up the axis of the crosses.

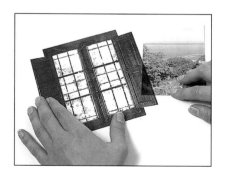

3 The landscape should now fit underneath the window frame shape.

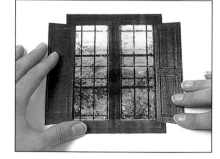

4 The window is placed over the landscape for the finished effect.

Overlaying translucent layers

An image photocopied onto tracing paper allows some detail to show through from below, but the colors and detail will be dulled.

How to overlay translucent layers

1 Skeletons of real leaves have been placed directly on a photocopier to make a highly detailed image on tracing paper.

Hold each copy over the background to see which one suits the background image best.

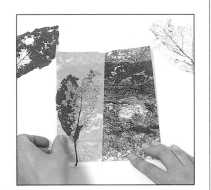

2 Once the choice is made, cut the leaf out using a scalpel for extra precision.

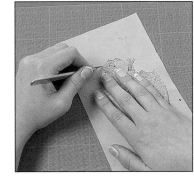

3 Finally, lay the cutout leaf on the background.

Overlaying non-transparent single- and multi-layers

Overlaying can be a single or multilayered process, or a combination of the two. Non-transparent layers can be laid over a background or over each other, allowing some of what is underneath to appear from beneath and around each overlaid image.

Overlaying a single layer over a background

1 The people, due to their size, make good middle-ground detail, so they are positioned on the shoreline and their arrangement is experimented with.

The seagull and starfish can now be added.

2 Once the remaining elements have been laid down in a strong formation, they can be mounted on the background using a dry glue stick.

The final result can then be glued to a backing of paper or cardboard.

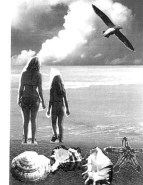

Multilayering

1 Create a background by overlapping large areas of vegetation. Add smaller images for the middle ground. Once the arrangement has been established, stick the layers in place.

Then position the foreground detail, here a bold daisy has been used, and glue in place.

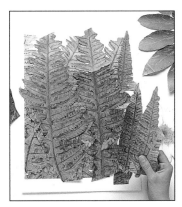

2 For finishing touches you could create different effects on the edges of some areas. Here pinking shears have been used to create a jagged grass-like effect.

This project is designed to allow you to make a landscape or scene depicting the contents of a photo album.

Covered photo album

The pictures can be compiled from a variety of sources, including your own photographs, of course. If the photos you have taken lack detail, you can add relevant items from newspapers, books, cards, packaging, and magazines.

This album contains photographs from a trip to Africa, so the scene covering it includes African landscape and animals. Naturally, your album will contain different imagery, so you should end up with a different scene, and even a different style of composition, to suit your particular album's contents and dimensions.

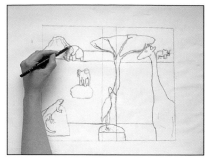

1 Draw a rough to the dimensions of your album. Select photos from the album, and make photocopies to fit the rough. Changes may be needed as you progress, so the rough is just a guideline. Always bear in mind the composition of the whole album image and give enough detail and balance to each half of the cover.

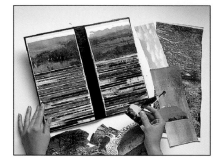

2 The photocopies can be altered in size. Here, some of the images, like the giraffe and the stork, have been stretched along their Y-axis to emphasize their height and to complement the dimensions of the photo album.

5 Once you have decided on the final arrangement, remove the smaller parts and hold the larger strips in place along the spine using a dry glue stick. Try for a tight fit that still allows movement.

To ensure that there is room for movement around the spine, score the paper with your thumbnail along the creases, starting with the innermost crease and working out.

6 Place the spine of the album in the center of each strip of background paper and fold them around the album.

Keep each strip taut and flip the overlapping edge over the edge of the cover to ensure the strips fit and also to create light folds at the edge and spine. This should be done to each strip and the whole process should be repeated on the other side.

7 Once the background strips have been folded, peel the paper away from the spine. Apply white craft glue (PVA) along the spine, then push each flap of paper firmly in position over the cover. Leave the glue to dry.

8 For an extra smooth fit you can apply glue over the album cover itself and flatten the strips into position.

Now the smaller detail of the background can be reintroduced. Once the formation is complete, the components, such as the mountain and elephants, can be glued in place and left to dry.

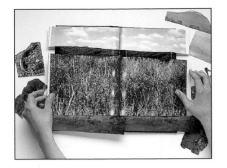

3 Lay the album out flat and begin to cover it with your photocopies. The main landscape areas have been copied in strips – sometimes using enlargement and X/Y zoom facilities to make them fit the spaces they are intended for.

The strips can then be laid down to create the main background, bearing in mind focus, color, and trueness to reality. Assess the overall effect and rearrange images if necessary.

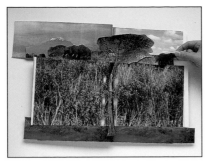

4 Other main background elements and detail can now be added, here the mountain, elephants, and an extra strip of bare earth. They can be slotted into place under or over the existing background and each other. Start to add detail to the other half of the album to create balance.

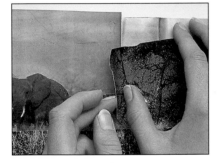

9 Any elements crossing the spine, such as this tree, need to be held lightly into place and scored along the creases.

Once the background has been stuck down the foreground detail can be added and stuck in place. Trim the extraneous edges of the paper down to the edges of the album and then glue the paper firmly to the edges of the album so the paper cannot peel off it.

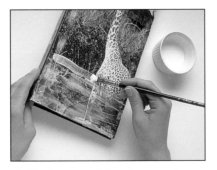

10 Finally, once all the pieces are in place, cover the whole book with a transparent protective layer of white craft glue (PVA) to seal the image and prevent tears, cracks, and scratches. Let the glue dry thoroughly before touching the album.

Safari album

j o h a n n a d e n n i s

This project involves the "building" method described in the techniques section. The subject matter should be a person you know, and you should use their physical characteristics, personality, interests, and surroundings as the inspiration for the choice of components to go toward making an image dedicated to them.

Caricature picture gift

A caricature tends to mean an exaggerated or surreal piece, perhaps with a humorous feel to it, which highlights certain distinguishing features of the person and invokes their character. You may want to do a more serious portrait using photographic elements to render the person's face, or you may want to use a photo of the face and manipulate it and combine it with other elements to make body, clothes, or the scene in which you want to place him or her. In the example shown, the humorous angle has been adopted and elements that show the person's interests have been juxtaposed to "build" the physical appearance. As it is intended as a gift, an affectionate tone has been attempted.

1 The first stage is to select the sides of the person that you want to evoke and the physical features that best sum up their appearance. Find some photos of the person's face, and find or take some photos that relate to their life, hobbies, and character, and plan how they can be rendered in the image. Once the rendering has been decided, the layout and imagery can be combined in a pencil rough.

4 Elements can now be arranged to create the head, body, and legs. Here, a television is the head; the remote control is the body; the guitar makes up the nose, mouth, and chin; and the skis become the legs. These elements can be kept in place using a bit of dry stick glue when the arrangement works.

5 Now create the face. Weather symbols (taken from photos of reports on television) are used as hair, eyes, and eyebrows. The positioning should be decided by looking at a portrait photo of the person to get a likeness. Mountains are used to suggest feet.

2 Basing decisions on your rough, begin to manipulate the photos and choose other imagery to use for body parts and surroundings. Here a stargazer's emblem has been created and repeated in strips in a color photocopy to eventually be cut up and stuck together in lines as a background. All the other elements chosen to be used are shown.

3 The background has now been glued together, and a strip of pinked green paper is being placed on top to create the grassy ground on which the figure will stand.

6 The arms and hands are now being built. Because of the subject's love of outdoor sports, the image's left arm is made from sunscreen tubes and the left hand is a starfish, while the right arm is also built out of sunscreen tubes and the right hand is a snowflake.

7 A soccer ball and a chameleon (chosen because of the subject's ability to adapt to his surroundings and the changes of outfits he requires for his sports) are placed to suggest some other hobbies.

The completed image can now be glued together, mounted and framed to be given as a gift.

Hobbies and Interests

johanna dennis

The original montages here demonstrate building a background, the imaginative use of stretching and manipulating color copies, cutting and ripping edges and overlayering. The effects achieved can depend on whether color or black-and-white photographs are used. In some of the work featured, the artists have hand-colored areas of black-and-white photographs.

Gallery

Johanna Dennis

Geography

Contemporary photocopy technology has greatly increased the techniques available to the collage artist. The artist used the stretch facility to elongate the buildings and trees in this landscape.

Wendy Wax

People & Clouds

This effective scene makes use of repeated figures and strong blocks of grass and sky textures. Semitransparent images have been layered over the bottom row of figures, making the reflections in the water more realistic.

Moira Clinch
Front Room

A collection of photographs, taken by panning the camera around the room, has created an impression that a single place and moment in time has been 'frozen'. Here the artist has included the same people appearing in repeat to add an unusual touch to the work.

Patricia Wheeler
Attic

LEFT: The edges between individual photographs have become an important element of this finished work. Freehand torn and cut edges have been cleverly combined, depicting both outside and inside in one atmospheric picture.

Using computer technology for creating collage gives you the opportunity to extend your ideas and practical talents in a completely different dimension, and transforms your creativity. With the countless possibilities which are accessible – all contained in some of today's leading painting, drawing and image-editing software packages – you have all the tools and special effects needed to create highly individual collage.

Computer Collage

One of the main advantages of creating computer-generated imagery is that once the necessary equipment and the technical knowledge essential for the construction and production of computer collage are available to you, the versatility of this medium allows you to edit images and apply special effects which cannot be created in any other way.

There are three pieces of equipment needed for art of this nature. The first two are obvious: A personal computer and the relevant software package that meets your needs. You will also need access to a scanning device, which may come in several different forms, including a flatbed scanner, a handheld scanner, or perhaps a photographing device that is simply a camera which stores your photographs and then allows you to plug the camera into your computer.

All of these devices allow you to download images onto your computer's hard drive. Software for creating collage comes in the form of painting, drawing and editing packages. The variety of effects that can be created really is inexhaustible.

Because of the nature of computer collage, deciding the theme on which you base your collage really is an open book. There are no restrictions as to the genre you choose, provided you can get your hands on the appropriate software and materials from the start.

Materials and properties

When you are collecting raw material which can be scanned in for use later, always bear in mind the subject you are working on. Having a mental picture of the kind of collage you would like to produce and making some sketches adds an element of fun to the selecting process. It will not only help you create a basis for beginning your collage, it will also give you some idea of the color and composition you would like to achieve. Once you have decided on a theme for your collage and have collected all your source material, you are ready to begin the technical process.

draw, cut and paste
Other functions allow you to draw, cut and paste, and reposition artwork on separate layers without affecting the rest of your layout, leaving you free to experiment with different combinations of blending, creating and adding textures and special effects, and using opacity.

filters
A significant breakthrough, available on many software packages, has been the introduction of image filters that produce remarkable visual effects, some photographic and some digital. These include blurring, ripples, dust and scratches, zigzags, and twirls.

visual sources: photographs

You may be able to obtain source pictures from your own existing photographs, or you could go out and take photographs, which could simply be of different-colored textures.

scanners

Using the visual material you have collected, the first process is to load all the images you will be using onto your computer's hard drive using a scanner. Every scanner comes with software that captures and converts visual imagery, graphics and photographs into electronic files that you can edit and use for creating your collage.

Scanned images can be saved on a floppy disk, then transferred to your computer. When you scan in images, the resolution (see page 128) determines how much detail the scanner records.

visual sources: CD-ROMs

There are also collections of stock imagery on CD-ROM that are available from picture libraries. These disks contain hundreds of images on various subjects, including images of animals, textures, landscapes, and flora and fauna. You can buy these compact discs in various subject categories, and all the images are free from copyright restrictions.

scaling images

You will also have the option to set the scale, which allows you to create smaller or larger images that do not have to be resized later. Scaling your image down saves space, especially if you are saving on a floppy disk, which usually has only enough room for a 1.3 megabyte file – a memory size equivalent to a very small image, or an image with a poor resolution.

To explain the workings of computers, all the equipment and software required, and cover the possibilities of computer graphics would take an entire book. In the following pages, we aim to give you an introduction only.

The basics

Types of images

Two main types of images can be created on a computer: vector images and raster images. Vector images are made of mathematically produced lines; such programs are usually used for putting together typography and graphics. Raster images are made of a grid of small squares, called pixels. Raster images depend on resolution and are usually used for working with tonal imagery. The images you scan in will be raster images.

Resolution: Pixel patterns

The resolution you set when you create a document determines the maximum resolution at which you can print the image. Image resolution refers to the pixels (or the dots) which make up a picture, how many pixels there are in every square inch, and how they are spaced in an image. The more pixels you have in your image, the higher resolution you will achieve.

Color codes

Once you have achieved the correct scale and resolution for your document, you should work in a color code which is normally Cyan, Magenta, Black and Yellow (CMBY). This form of color is the standard color code for printing. Once you have checked all these things, you can begin to put together your collage using a computer.

Creating a document

Once your material is scanned in and accessible from your computer's hard drive and you have opened the relevant software file, the next step is to create a document.

When you have achieved the correct scale and resolution of your document, you can begin to sift through your scans inside the computer's application and select the parts you want to use and load them onto your document.

Saving your work

Once you have completed your work, you will need to know how to save it, so you can print it out. There are many different kinds of file formats, each with a different name and function. The most recognized file format is called a TIFF. file, which stands for TAGGED-IMAGE FILE FORMAT. This form of file is very flexible and lets you exchange documents between different applications and computer platforms. It is also very reliable because of its compatibility with other computers. If you are having an image printed out by a print shop, for instance, TIFF. files are always recognized. When you save your image, you must give your picture a name; if your collage was a picture of an apple, for example, you might call your file *Apple.tiff.*

Getting your work printed out

When your work is finished, you will want to see the final product printed out on paper. It is always exciting to see a printout, because the colors on the screen always differ slightly from the printed product. First, save the image on a disk as a TIFF. Unless you have your own printer, you will need to take your disk with the artwork to a print shop, where the technicians should be able to answer questions about the color code and give you several output mediums to choose from. Laser printing and dye sublimation printing both give good results if your image is at a high-enough resolution.

There are many versions of computer hardware and software programs on the market, and each system may use different terminology and symbols. We cannot be comprehensive here, but the following pages should help you with the basics.

Using basic tools

Features you will recognize, even if you are not acquainted with the latest packages, are the regular tools, which comprise pencil, paintbrush, and airbrush. In addition, there are tools available which allow you to manipulate the image you are working on in a number of different ways. For example, the select tool allows you to make freehand, rectangular or elliptical selections from your image. Selected areas can then be manipulated with a multitude of functions, including rotation, cut, copy, move, perspective, distort, and fill, each of which can either be in gradual or block color. All of these features create distinctive results. Using the erase tool with the layers option, editing your work becomes incredibly easy.

 Pencil tool: Allows you to paint hard-edged freehand lines.

 Airbrush tool: Allows you to spray a diffused layer of color onto an image.

 Paintbrush tool: Allows you to paint soft-edged strokes.

 Gradient tool: Allows you to fill in gradually from one color to another.

NB: **Menu bar symbols vary between manufacturers.**

Creating a ripped effect

1 Scan in a picture of newspaper text.

2 Using the freehand selection tool, mimic the shape of a ripped piece of paper. When you have selected a rip shape, select cut or copy from the edit menu. The example shown here has a black line where the selection has been made.

3 On a new document, which will be your ripped-effect image, create a black background. Next choose paste from the edit menu, and paste the rip shape into your picture.

Repeat step 2 and paste as many rips as you require into your picture.

Color and painting tools
By overlaying the same color with either the paintbrush, pencil or airbrush, different densities of color will emerge, effective for creating things like clouds and water.

To produce color mixtures, overlay different colors. For example, if you overlay red with yellow, an orange mix can be produced. This process can be a good way of creating shading and shadows.

Using pencil tool	*Using airbrush tool*	*Using paintbrush tool*	*Using gradient tool*

1 Creating a zigzag pattern over a blue background.

1 Different-sized brushes overlaying different colors.

1 Using different-colored paints, strokes and brush sizes over a red background.

1 Two different-sized squares overlaid using linear gradient tool with light green to dark green.

2 Creating a freehand pattern.

2 Sweeping the airbrush from left to right, using quite a large brush and orange, yellow, and red colors.

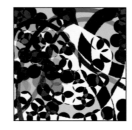

2 Using strokes and dots, overlaying color.

2 Directing the linear gradient tool from bottom left corner to top right.

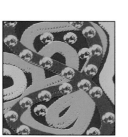

3 Using a large pencil, creating a random freehand design over a red background.

3 Starting with a large airbrush, then changing to a smaller brush using different colors.

3 Creating a swirling pattern with subtle colors.

3 Radial gradient tool, using blues.

1 Create a rectangular or square document in any size. Draw random lines using different density blues. Work across from left to right using the line tool from the systems tool box.

2 Begin to introduce vertical lines, and some more horizontal lines, using blue and red paints with the line tool.

3 Add more lines, changing the thickness of the line if you feel the image needs it for balance.

Drawing and cutting tools

Using the select tool creates edges with different properties. This process is the computer equivalent of drawing a shape you want to cut out on a piece of paper and then following around the edge of the line with a pair of scissors.

Ripped and jagged edges can both be achieved using the freehand selection tool. Working from another open document, which should be one of the pictures you scanned in, you can draw the kind of edge effect you want to achieve. Then cut and paste the shape into the document you are working on. Straight, circular, and zigzag edges can also be achieved, but instead of using the freehand selection tool, you will use the rectangular or elliptical selection tool. To achieve a similar feel to that of overlaying tissue or tracing paper, you can manipulate images using an opacity selection tool that gives you the freedom to overlay different colors in a variety of shapes.

Making a gradient circle picture

1 **2**

3 **4**

1 After creating a square-format document, use the line tool to split the image into quarters. Next, select the top left-hand square of your image using the rectangular select tool, which lets you work just on this section. Using the radial fill option, draw a line with the cursor, from the middle (which is the bottom right corner of the selected square) to the top left-hand corner and release the button on your mouse. This creates a quarter circle (see picture 1).

Repeat for each of the other squares using different colors for each square. When you reach the final square, you will have created a circle (see picture 4).

The demand on software developers and manufacturers to meet the needs of the computer artist and commercial trends has led to the development of software which allows you to indulge in an assortment of special effects that will add a beautiful finish to any collage.

Special effects

Computer collage is very different from any other form of collage art, and the special effects that can be created are dramatic and exciting.

Layers

Layers enable you to edit specific areas of your image without disturbing the other data. When you reach the final stages of your collage, you may need to restructure and clean up rough edges. Having layers enables you to edit specific areas of your work, without affecting the entire image. Because each layer is independent of the others, you have scope to experiment with different combinations within the software package without having to worry about making mistakes.

1 With the elliptical select tool, draw a circle in the center of the document. Then fill the selected area with black to make a black circle.

2 Next, select the radial fill selection from the gradient tool option.

Over the top of the black circle, using white for the foreground color and gray for the background color, use the mouse to draw a line with the cursor, from the point at which the impression of light is coming from, to the near opposite side of the circle.

By releasing the button on the mouse the effect should give the impression that light is shining on a round object.

These two images from the Seaside *picture project on pages 138–139 show the use of layering. The starfish is on one layer and the dolphins are on another; different effects can be achieved by bringing one or the other to the front.*

Overlaying opacity lines

1 Create a document, and choose the paintbrush from the tool box. Choose blue paint with an opacity level of 70%. Draw random freehand lines which overlap each other.

2 Introduce some different colors, changing the direction of the marks as you add each line with the paintbrush.

3 Choose more colors from the software's paint palette. Keep overlapping the lines and a design with varying tones of color will begin to emerge.

Creating a stippling-effect painting

1 Scan in a photograph of some flowers.

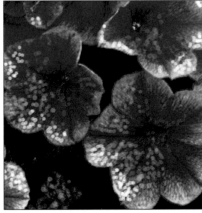

2 Using the paintbrush, select similar colors to those of the flowers and begin making a series of small dots with the paintbrush over the top of your photograph.

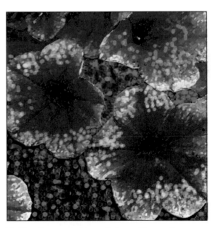

3 Continue making dots until you have covered your picture. This creates a stippled effect and is a good way of making a photograph look like a picture you have painted.

1 From any appropriate scanned image, cut out a hexagonal shape and a square shape.

2 Copy the hexagon from the scanned document and paste it into the new document as many times as it will fit into the top part of the picture.

3 Continue this procedure, aligning the hexagons to create part of the patchwork pattern.

BELOW: Elements of the patchwork images.

4 The next step is to select the square shape you cut out earlier and rotate it so that it becomes a diamond shape.

Copy the diamond shape, and paste one into each of the white diamond spaces left in the patchwork image.

5 When there are no large white areas left, the patchwork pattern is complete.

Creating three-dimensional images

Perspective is easy to create using a perspective tool that allows you to create a three-dimensional effect to draw the eye's attention into the picture. This function allows you to distort imagery, which is useful when you are manipulating layers.

Creating a perspective picture

1 Begin by making a series of black-and-white squares in a square format document. The easiest way to do this is to start with a white background. Then select a square and fill it with a flat-black color. Place it in the top left-hand corner. Copy and paste squares in a check pattern like a chess board.

Copy the document and paste it into a new document. Place the checked box in the lower central part of the screen.

2 Once you have placed the checked box, select it with the selection tool. Then using the perspective tool from the effects menu, drag the two bottom corners of the box outward to the two bottom corners of the document image. This creates a very effective tiled floor in perspective.

3 Next we are going to create a back wall. Using the rectangular selection tool, draw a rectangle with the same width as the furthest point of the floor. Fill the square with a light gray color.

4 The next step is to create the walls. Using the rectangular selection tool again, draw and fill a rectangle on each side of the back wall. The width should cover the space between the back wall and the edge of the picture on each side, and the height should be the same as the back wall. Fill these rectangles with a slightly darker shade of gray.

5 Select the side wall rectangles one at a time and use the perspective tool again to drag the two corners nearest the outside edge of the picture to the top and bottom corners. When you do this on both sides, the picture will begin to look like a room.

6 The next step is to finish the room by installing a ceiling. Select the white area left at the top of the picture in step 5 and choose the linear gradient tool. Using a foreground color of light gray and a slightly darker background color, fill in the remaining area.

This design would look great for a set of table mats for everyday use or for special occasions.

Table mat design

You can use any images you choose for this type of copy and paste design, but it is best to sketch out a plan for using your images to make sure they work in a repeat pattern like this.

1 You will need the following scanned images to create your collage: a clouds background – you can create this by spraying gray with an airbrush on top of a yellow background; dried flowers and grain; grapes; leaves; and a bud.

To begin creating this collage, create a document which is 4 × 2¾ inches (10 × 7 cm).

2 Select the yellow and gray clouds background and paste it into the document. Scale the image up, using the scale tool from the effect menu, until it fills the whole document to create the background layer ("Layer Four").

TIP

To create a set of coasters, select and copy a favorite square-shaped selection from the final image. Then save it as a different document under a different name.

To be able to finish your table mats and coasters properly, save the final image on disk and get it printed out. Then get them coated in plastic using a process called laminating. Many print shops offer a laminating service.

6 The next step is to select and copy the grapes from your scanned image. Because the example scan has a corner cut out in the bottom right of the image, it is easier to paste the grapes into the corners of the table mat document.

Select the grapes and on "Layer Six," rotate and paste a separate bunch of grapes every 90° in each corner.

7 For "Layer Seven," paste the first of the dried flowers and grain.

Select from the scanned image as before and paste the first section down, scaling it as shown in the example into the left-hand middle section of the picture.

8 Now, using the paste and scale tools, paste and scale the same image, flipped vertically to produce a mirror image of the original dried flowers and grain. Then paste the copied mirror image on the left-hand side as shown. This is all "Layer Seven."

Repeat as above, rotating, moving and pasting the image, until you have four double bunches of dried flowers and grain in the spaces between the grapes.

3 Select leaves and paste them into "Layer Two" in the table mat document. Rotate the leaves using the rotate tool, and place the first cluster of leaves in the top right-hand corner.

4 There is no need to select the leaves again. Just add another layer ("Layer Three") to the document, and rotate and paste the leaves in the opposite corner from the leaves in step 3.

5 Add another layer of leaves to the top left-hand corner of the collage, and make it "Layer Four." Repeat steps 4 and 5 to add leaves and paste them into the bottom right-hand corner to make "Layer Five."

9 Go back to the scanned images and select the bud picture. Copy and paste it into the table mat document. Then paste and rotate the bud in the center of the collage, pasting one bud at a time, rotating each bud so that the spiky bits are facing outward, toward the edge of each corner of the picture.

Grapes, Berries and Grain

jayne dennis

The versatility of working with computer images means that you can create very imaginative collages.

Seaside picture

This picture would be ideal for a bathroom, especially if your decoration has an ocean- or sea-based theme. You can, of course, use any images which relate to a particular theme of your choice.

1 You will need to collect the following scanned images to put together your collage: rubber ring; a hand-drawn scanned picture of a dolphin; a picture of a cloudy sky; a photograph of sand; a starfish; and a photograph of water.

To begin your computer collage, you need to create a document at a scale of 3 × 3 inches (8 × 8 cm) giving it a color code mode, see page 128.

2 From a scanned- or gradient-finished image of sand, select the whole sand image, copy it, and paste it into your seaside document.

The shape of yellow sand will probably need to be rescaled depending on the size at which you created it. When you rescale it, fit it into the bottom part of your image using the scale tool. Make the sand layer "Layer One."

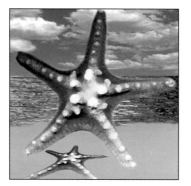

5 Now we are going to create a smaller starfish to go into the sand. Duplicate "Layer Two" in the layer options menu to make a "Layer Two" copy. With the copied layer selected in the layers window, you will not be able to see a copied version at first, because the copied layer is directly over the top of the first starfish layer.

To give the copied starfish perspective, use the same method as described on page 135 to make the starfish smaller and in perspective. Then move it to a suitable position, as shown in the example.

6 Make another copy of the starfish from the "Layer Two" copy, and call it "Layer Two Copy Two."

Move the "Copy Two" starfish to another position in the sand.

7 Copy and paste the dolphin from your scanned image three times into "Layer Three." The dolphins will appear over the top of the large starfish.

To make the dolphins appear behind the starfish, you move "Layer Three" behind "Layer Two," by moving the layer settings in the layers option window.

3 Select and copy the picture of water and paste into the same layer. Scale the water to fit into the middle section of your picture. When the water is correctly placed, deselect it and make it part of "Layer One."

Repeat for the sky image, scaling it so it fits into the top area. Deselect it and make it part of "Layer One" to complete the background layer.

4 Select and copy the starfish, then go back to the picture document.

Create "Layer Two," and paste the starfish into the picture. Scale the starfish up or down using the same tool as before, so that it is about the same size as this example.

9 The final step is to create "Layer Four." Go back to your scanned images, then select and copy the complete image of the rubber ring.

Paste the rubber ring into your final layer. Using the scale tool from the effects menu, scale the ring up until the outer edge is no longer visible, thus creating a circular frame for the collage as shown.

8 The next step is merely to change the balance of the picture. Since the starfish looks like it is floating in midair, we need to move it so that the bottom points of the star are out of the picture.

Select "Layer Two" in the layers selection window, and use the move tool to move the starfish down as shown.

Dolphins and Starfishes

j a y n e d e n n i s

The breadth of work possible with modern computer technology is illustrated in the pieces in this section. Most images can be scanned into a computer allowing almost infinite source material. Once scanned in, the images can be manipulated beyond recognition with perspective effects and using techniques such as multilayering to add to the originality of the work.

Gallery

Jayne Dennis

The Birth of a World

This work uses perspective to convey the feeling of time and space. Inspired by the increasing effect of technology on modern life the artist scanned in painted images and manipulated them using a variety of techniques including stippling and layering.

Peter Gudynas

Bio-Cerebral Infusion

RIGHT: Images relating to science fiction and science fact have been manipulated and used as a basis for this futuristic work. Inspired by technology the artist has created a vividly colored vision of what is in store for humans.

Jan Ostrowski

The First Question

LEFT: Scanned photographs of assembled found objects layered over a photo of a handbuilt wooden frame create this highly textured work inspired by theories about the beginning of time.

Richard Holloway

The Culture of Science

Multiple layering techniques have been used to create this work which features ancient and modern themes inspired by Eastern and Egyptian cultures. The artist combined images shot on a digital camera and photodisc with a series of subtly colored collected images.

Index

Credits

Quarto Publishing would like to thank all of the artists who have kindly allowed us to reproduce their work in this book.

We would also like to acknowledge and thank the following artists whose work has been used at the opening of each chapter: page 2 Nancy Gibson-Nash *Fusion*; page 9 above right Karen Howse *Silbury Hill and Morvah Stones III*; below right Joan Jago *Music for the Harpsichord*, below left Sophie Marsham *Untitled*; page 10 above Henrietta Hine *Reef Shoal*, center Cas Holmes *Frog*, below Randy Frost *Beneath the Surface*; page 18 Shirley Brinsley *Bird*; page 36 Nancy Gibson-Nash *The Brown Chest*; page 50 Jean Davey Winter *Threshold*, courtesy of Comesim UK, London; page 64 Sue Barry *Bird in the Sky*; page 80 Jacqueline Myers above *Arc Pin*, below *Zig Zag*, right *Reversible Fibula Pin*; page 94 Lauren Ling Future *Security*; page 108 Sean Hillen *Cosmonaut Lands in Annalong Harbor*, *Security Forces Investigate*; page 124 Jan Ostowski *Analysing the Future*.

All other photographs are the copyright of Quarto Publishing.

We would like to thank The London Graphic Centre, London, for supplying art materials used in photography.

Typeset by Type Technique Ltd., London
Manufactured by PICA Ltd., Singapore
Printed by Star Standard Industries (Pte) Ltd., Singapore